SECRET
MANCHESTER

Phil Page & Ian Littlechilds

AMBERLEY

First published 2014

Amberley Publishing
The Hill, Stroud, Gloucestershire, GL5 4EP
www.amberley-books.com

Copyright © Phil Page & Ian Littlechilds, 2014

The right of Phil Page & Ian Littlechilds to be
identified as the Authors of this work has been
asserted in accordance with the Copyrights, Designs
and Patents Act 1988.

ISBN 978 1 4456 4019 8 (print)
ISBN 978 1 4456 4028 0 (ebook)

British Library Cataloguing in Publication Data.
A catalogue record for this book is available from the
British Library.

Typesetting by Amberley Publishing.
Printed in Great Britain.

Introduction

Many places in this book will be well known to visitors and residents of Manchester. We have lived and worked in the city for over thirty years, have visited the city centre countless times to shop, eat, drink, enjoy cinema and theatre, or just to browse and enjoy the architecture of a great Victorian city. However, in the short space of time we have been compiling this book, we have discovered many secrets and hidden stories within these popular places, which the casual visitor can easily overlook. This book aims to point you in the direction of some of these lesser-known facts surrounding Manchester's city centre history and culture. You may have visited these places several times but, like ourselves, missed out on their hidden secrets that have always been within touching distance.

The book is divided into six chapters, with each covering an area of the city that has developed its own identity. We have tried to include places in each area that are worthy of further discovery. Inevitably, we have not been able to include every place of interest within the city centre, but we hope you may be inspired to make your own discoveries outside the scope of this book.

What the six areas show, is that although they are all within walking distance of each other, they all have a self-contained history in the way each has developed over centuries or, in some cases, only the last few decades.

What is without question is that Manchester is a place that holds many delights to the million visitors who head into the city each year. The culture of Manchester has developed artistically, architecturally, theatrically, musically and politically over the years, and it is no surprise that it is the second most visited city in England outside London.

We hope you will enjoy wandering around each of the areas mapped out in this book. Within each journey there is time to stop, discover and chat about many of Manchester's hidden secrets, whether you are a first-time visitor or a local who enjoys wandering around your own streets. There are plenty of places to rest along the way. Manchester is not short of places to eat and drink, or green spaces in which to relax and watch the world go by. You may well be distracted by the many shopping opportunities along the way, and the excellent pubs, bars and restaurants that you will encounter. However, keep your eyes open. You never know what you may discover.

1. Around Castlefield

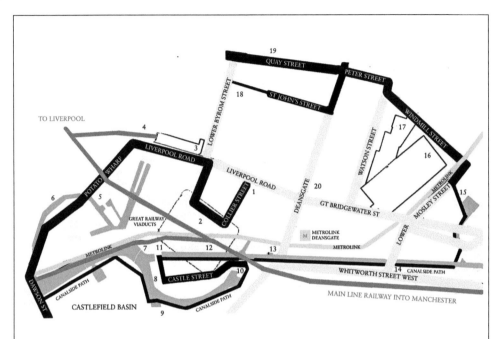

1 WHITE LION PUB
2 ROMAN FORT SITE
3 MUSEUM OF SCIENCE
 AND TECHNOLOGY
4 LIVERPOOL ROAD STATION
5 GIANT'S BASIN
6 RIVER MEDLOCK
7 SITE OF KENWORTHY WAREHOUSE
8 MERCHANTS' WAREHOUSE
9 MIDDLE WAREHOUSE
10 GROCERS' WAREHOUSE

11 DUKE'S LOCK
12 ROCHDALE CANAL
13 DEANSGATE TUNNEL
14 SITE OF THE HACIENDA
15 BRIDGEWATER HALL AND
 CANAL ARM
16 CENTRAL STATION SITE
17 GREAT NORTHERN WAREHOUSE
18 ST JOHN'S GARDENS
19 OPERA HOUSE
20 BEETHAM TOWER

Introduction to the Castlefield Area

The walk around Castlefield will take you on a journey from the Roman development of Manchester through to the industrial grandeur of a thriving Victorian city.

Castlefield was chosen by the Romans as a suitable settlement as it was situated on a rock outcrop and protected on two sides by the Rivers Irwell and Medlock. The remains of the original fort, constructed around AD 79, provide the first definite evidence of human settlement in Manchester.

The first quay in Castlefield was constructed in 1734 after the River Irwell had been made navigable and trade between Manchester and Liverpool was made possible. Quay Street was constructed between Deansgate and the river, and James Brindley engineered the first canal in Britain to transport coal from the Duke of Bridgewater's mines at Worsely into Manchester. From then on, Castlefield developed into a busy canal hub, which resulted in the building of a number of grand warehouses, some of which survive to this day.

With trade expanding quickly, the canal routes could not cope with the transport demands and the railway was brought into the area with Liverpool Road Station being opened in 1830. The area soon became criss-crossed with viaducts to enable the transport of goods and passengers to different locations outside the city. Further viaducts extended the railway into the city itself, with Central Station opening in 1879.

With the decline of canal and rail transport in the twentieth century, much of Castlefield fell into disuse, but, with the establishment of the area as a heritage park in 1982, the surviving buildings and waterways underwent an extensive programme of refurbishment. The area is now a thriving part of the city with its pubs, bars, canal moorings and open spaces for concerts and public events.

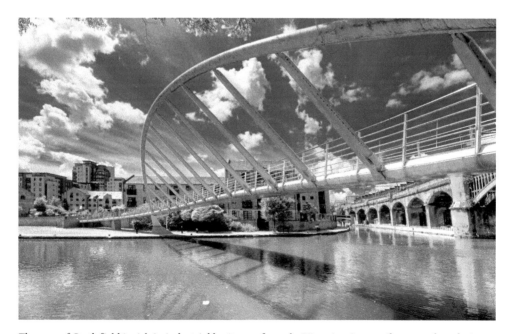

The area of Castlefield is rich in industrial heritage – from the Victorian Age to vibrant modern designs.

Castlefield Roman Fort

Our exploration of Castlefield starts at the entrance to the Roman Fort Excavations outside the White Lion pub on the corner of Collier Street and Liverpool Road. Walking into the gardens, you are at the place where Manchester actually began. When the Roman Fort was first constructed, circa AD 79, it was possibly one of a chain of forts that guarded this route.

The area is dominated by a large stone gateway, which is a reconstruction of how the northern entrance to the Roman Fort would have appeared, rebuilt in stone, at the time of the Roman occupation around AD 200. The reconstruction took place in 1986 and was taken from known British and European designs

Much of the stone from the fort survived through the centuries, but it was the Industrial Revolution that eventually destroyed most of the remains as the Castlefield site was redeveloped with its series of roads, railways and industrial warehouses

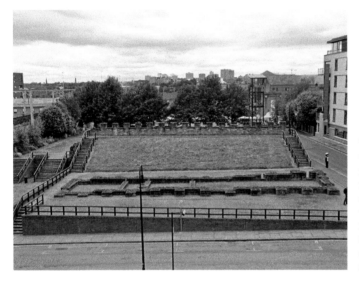

The long, thin remains to the north of E. A. Burton's 1907 excavation were first identified as a granary or a barrack block. However, the consensus of opinion is that it was a granary raised from floor level to allow aeration and the safe storage of grain.

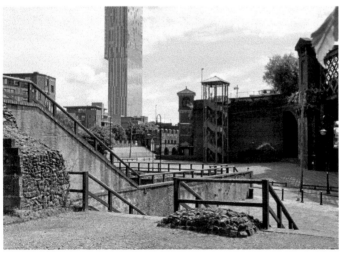

Further excavations undertaken by The University of Manchester in 2003 discovered fragments of remains of the north-western corner of the fort, dating from the early third century This view across to the reconstructed northern gate shows both entrances and the extent of the main area of the fort.

Liverpool Road: The World's First Passenger Railway Station

Liverpool Road station was the eastern terminus of the world's first passenger railway linking Liverpool and Manchester. Passengers entered this station from Liverpool Road and the booking halls, which can today be accessed from inside the museum. When the line was opened in 1830, it was regarded as one of the greatest transport achievements of the century, particularly as difficult engineering projects had been undertaken to allow the line to arrive in the east of the city. The line had to be bridged across the Irwell floodplain and then had to clear the Irwell at a sufficient height to allow the passage of river traffic beneath the line. Eventually, the line had to arrive at the top of the sandstone bluff on which the station buildings stand with enough space to incorporate the infrastructure of a passenger-goods terminus.

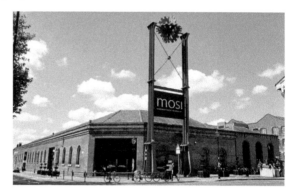

The Museum of Science and Industry charts the development of Manchester's heritage through a large collection of exhibitions and hands-on experiences.

The entrances to the first- and second-class booking halls were situated on Liverpool Road. Once tickets had been purchased, passengers would ascend the stairs to waiting rooms that led out onto the platforms.

The station opened on 15 September 1830 and was the starting point for the world's first inter-city passenger service. It closed to passenger services on 4 May 1944, when the line was extended to join the Manchester-Leeds Railway at Victoria Station, near Hunts Bank, across the city.

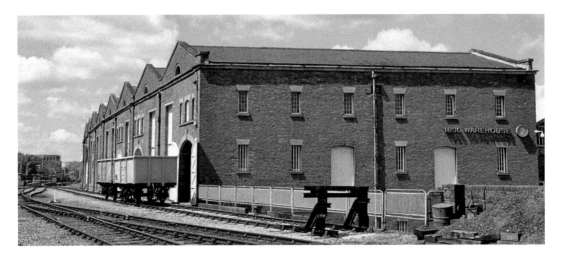

The impressive Liverpool Road Warehouse that sits opposite the station buildings was erected in only five months and, as building design was in its infancy, has the style and loading facilities more in keeping with a canal warehouse.

The Archive Collection at MOSI is well worth exploring as it holds much archive material relating to the development of Manchester as an industrial city. It includes a number of collections relating to the great Manchester companies, such as Ferranti, Mather and Platt and GEC Alsthom. There are original textile pattern designs from the Victorian era and a collection of memorabilia from the The Haçienda nightclub.

The designs for this magnificent engine can be viewed in MOSI's archive collection.

The Giant's Basin

Leaving the Museum of Science and Industry, turn right into Liverpool Road and, just before you reach the roadside entrance of the station buildings, turn left into Potato Wharf and head south under the railway bridge. Immediately on the left is the Manchester YHA, and situated immediately opposite is The Giant's Basin, which sits adjacent to the end of the Bridgewater Canal spur.

The remains of the canal basin, and the Bridgewater Canal at this point, are among the best preserved industrial period monuments in the country and remain examples of two of the great engineering projects of the time. The Canal itself ran across existing watersheds without relying on the courses of streams or rivers.

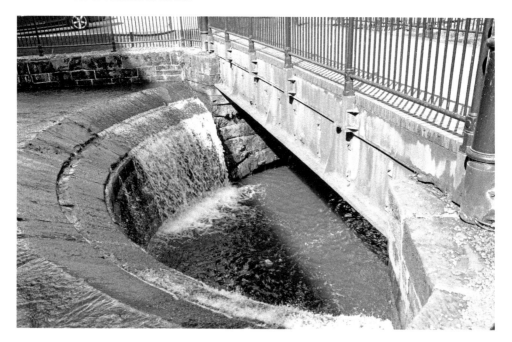

Above: The construction of the canal basin involved redirecting the bed of the River Medlock via an overflow sluice on the eastern side of Deansgate, which took surplus water to a tunnel below via the Giant's Basin. This giant, clover-shaped weir on the western side of the canal basin was designed to manage the water flow into the basin.

Right: A stone bridge on the opposite side of Potato Wharf crosses the River Medlock, and from here, you can see the two sluice tunnels through which overflow water from Giant's Basin was dispersed.

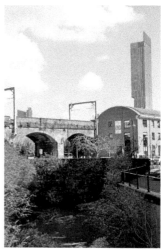

After leaving Giant's Basin, follow the cobbled roadway until it brings you to the busy A57. Turn left under the railway bridge and across the Bridgewater Canal, then immediately turn left down a narrow alleyway that takes you to the southern bank of the waterway via a small metal bridge.

As you continue along the canal bank towards the Bridgewater basin, the skyline is dominated by the Beetham Tower. Cross over the wooden lift bridge, which links two of the loading basins and, as the canal turns, to your left, you can see the site of The Kenworthy Warehouse.

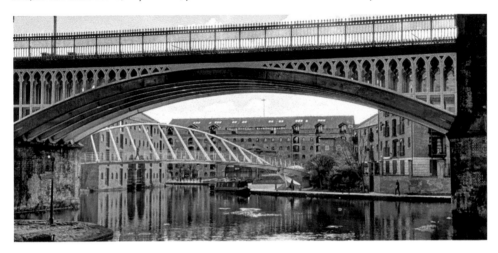

The Castlefield basin is of huge industrial archaeological importance, mainly due to the survival of a number of fine Victorian warehouses that dominate the area. Between around 1770 and the late 1840s, six warehouses were built around the canal basin and were a mix of company and privately owned premises. Many of these great warehouses survive today and have been converted into private use.

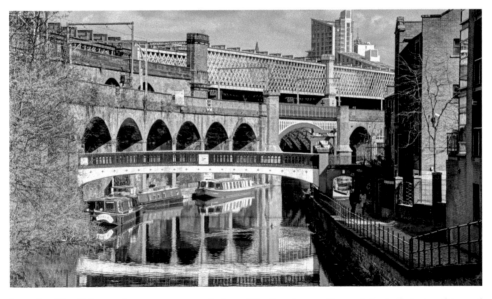

From the side of the canal you can get a good view of the four huge railway viaducts that span the canal basin, all of which intersect at a point around 300m west of Deansgate Station.

As you walk under the white, curved Merchant's Bridge, you can see the Merchant's Warehouse immediately ahead of you on the left of the canal. It was built around 1827 and is typical of canal warehouse design of the time.

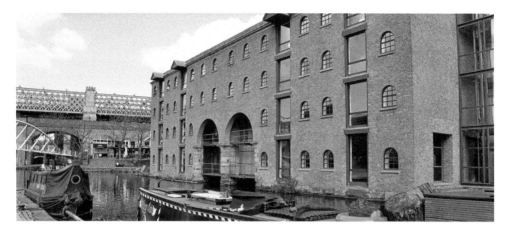

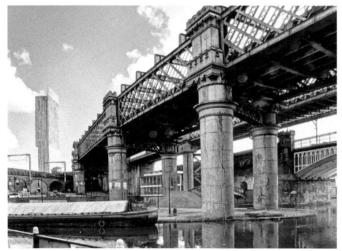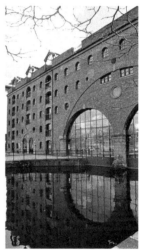

Top: Originally a four-storey warehouse, The Merchant's Warehouse had two shipping holes and, on the street side, six loading bays topped by wooden catsheads (or hoods).

Above left: Standing on this site, and originally six storeys high, The Kenworthy Warehouse was built on an arm extending out from the Giant's Basin. It was primarily designed as a heavy goods store handling oil, cotton, flour and grain, but after the railway viaduct was built across the site it was eventually demolished in 1964.

Above right: As the canal bears right, immediately ahead of you stands the much larger Middle Warehouse, which was built in 1831 by the Manchester Ship Canal Company. It is situated on the south bank of the basin in its own canal arm. The two undercover loading and unloading bays can be seen at the front of the building.

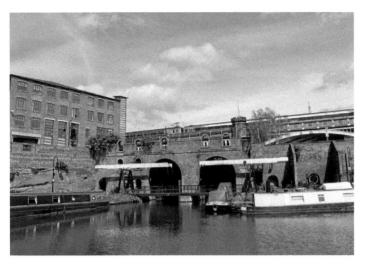

The Grocer's Warehouse was designed by James Brindley and was cut back into the red sandstone rock face to the north of the Medlock. Today, part of its façade has been restored and the canal arms are linked by two Dutch-style lifting bridges.

The site of the Duke's Warehouse, which was constructed in the 1770s, and was a four-storey structure with a floor of over 2,000 m. It was destroyed by fire in 1789, rebuilt and then burnt down again in 1919.

Manchester South Junction and Altrincham Railway Skewed Bridge

Cross over the metal bridge and up the metal stairs on the side of the Grocer's Warehouse. At the top, turn left onto the cobbled road of Castle Street, taking in the skewed railway bridge above the canal and the rebuilt roof of the Grocer's Warehouse, and follow the road round until you come to Dukes Lock on the Rochdale Canal.

This line was one of Britain's first purpose-built suburban lines and turned the market towns of Stretford and Altrincham into dormitory towns for the Manchester middle classes. The stations along this line have now been rebuilt to accommodate the Metrolink tram service, with the exception of Old Trafford, which still has its classically designed booking hall that was built in 1856.

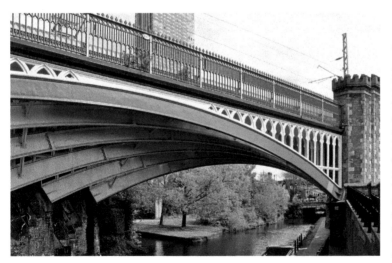

The Manchester South Junction and Altrincham Railway was opened in 1849, and this bridge forms part of a viaduct of 224 arches that carry the line from Piccadilly Station in the east to Liverpool Road in the west. Just after the bridge, there is a spur line that goes in a south-westerly direction, across Castlefield Basin to Cornbrook and on to Sale and Altrincham.

The Rochdale Canal

Just after Lock 92, the Rochdale Canal enters the Bridgewater Canal Basin. This waterway through the city dates from 1776, and this section linking the Ashton Canal and the Bridgewater Canal proved to be one of the most profitable stretches, but most of its length was closed in 1952 and, by 1960, in navigational terms, it had become mostly unusable.

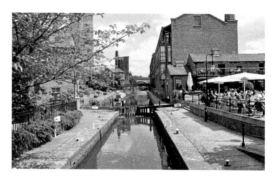

Lock 92 on the Rochdale Canal. Dukes 92, a modern café bar and restaurant, has been established in the old stable block, which was used to house horses delivering food and other consumables from the Merchant's Warehouse opposite.

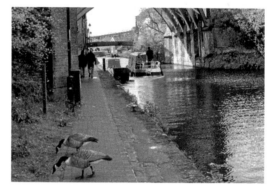

Funding of £23 million from the Millenniumm Commission and English Partnerships has resulted in the entire length of the Rochdale Canal becoming operational again for leisure traffic, almost 200 years after its initial opening.

The Deansgate Tunnel

As you reach the towpath, turn right and head east towards the Deansgate Tunnel. As you pass through the tunnel you arrive at Deansgate Locks, the name of which is carved into the top of the old railway buildings on the north bank of the canal. A few hundred yards walk along the canal brings you to the rear of a large block of apartments, which mark the site of the legendary Haçienda nightclub.

The Deansgate Tunnel is approximately 200-yards long and takes the Rochdale Canal under Whitworth Street and the lower end of Deansgate.

The Site of the The Haçienda

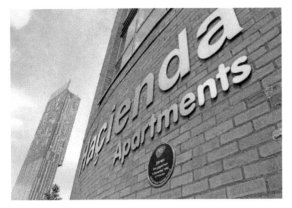

Today, the site of the The Haçienda is a block of apartments that bears its name. However, behind the apartments, on the wall that parallels the Rochdale Canal, is a metal timeline documenting important events in The Haçienda's history and some of the more famous artists who played there throughout those heady 'Madchester' years.

Tony Wilson was instrumental in the development and success of The Haçienda.

The Haçienda rose to fame in the late '80s and early '90s. It opened in 1982 and, despite continuing financial troubles, remained open until 1992, largely because of financial support from the band New Order. The original building was an old warehouse and had a history as a yachtmaker's premises and a Bollywood cinema before its conversion into a nightclub. It was largely financed by Factory Records, under the direction of Tony Wilson

During its time, it hosted some internationally famous performers, including The Smiths and Madonna, and pioneered house music discos. The club was eventually demolished in 2002 when the site was acquired by Crosby Homes. Their advertising slogan, 'Now The Party's Over You Can Come And Live Here' was not well received by those connected with the club.

the haçienda closes saturday 28 june 1997

The Haçienda was finally closed on 28 June 1997. The final live set was performed by Spiritualized on the 15 June 1997.

The Bridgewater Hall and Canal Arm

After leaving the site of The Haçienda, a short stroll will bring you to the entrance to the Bridgewater Canal Arm.

During the late eighteenth and nineteenth centuries, the transport links around Manchester went through a significant period of development. A significant feature of the canals around the city centre were the side branches or short, private canal arms. By 1808, there were six canal arms radiating from the Bridgewater Canal serving the important warehouses in the Castlefield area, and by the mid-1800s, there were around seventy such developments along stretches of the Ashton, Bridgewater and Rochdale Canals.

Today, most of these canal arms have been filled in and are no longer recognisable along the city centre canal system. However, this one running northwards off the Rochdale Canal, just off Chepstow Street near Oxford Road, mostly survives, with its basin providing the backdrop to the Bridgewater Hall concert venue.

Cross over the curved metal bridge onto the northern side of the canal and then left under the small narrow bridge that follows the canal arm round to the basin outside the concert hall. As you head up the steps from the canal basin, you arrive in Barbirolli Square, with the hall itself on your left, G Mex, the old Central Station in front of you, and the Midland Hotel on your right.

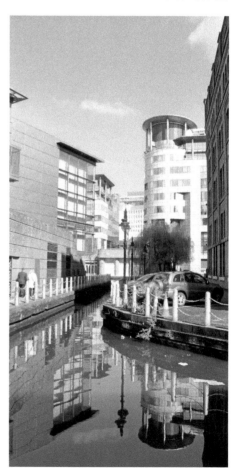

The Hall was opened on 11 September 1996 and incorporates a number of interesting features in its construction relating to acoustic design. The main auditorium, designed by Rob Harris, sits on a foundation of earthquake-proof bearings that protect it from the noise and vibration of the traffic in the surrounding area. The building has a stainless steel outer shell, with the lower part of the hall constructed from deep red sandstone from the Corsehill Quarry in Annan. The interior is similarly impressive, being constructed mostly of Jura limestone.

Outside the Hall, on the bank of the canal arm in Barbirolli Square is the Ishinki touchstone, a sculpture of polished, Italian Carra marble designed by Kan Yusada. The stone weighs 18 tons and was installed in August 1996. Beside the main entrance to the hall is a sculpture of Sir John Barbirolli. Barbirolli is widely credited with reviving the Halle Orchestra after the Second World War and spent twenty-five years as its principal conductor, retiring in 1968.

Passage to the Bridgewater Canal Basin is via a narrow passage from the spur on the Bridgewater Canal.

The Bridgewater Canal Arm connects the Bridgewater Canal Basin via a spur off the Bridgewater Canal.

The Ishinki Statue dominates Barbirolli Square.

Manchester Central Station

As you stand in Barbirolli Square, immediately in front of you, across Lower Mosely Street, is the building that was formally Manchester Central Station.

Manchester Central Station (now the Manchester Exhibition Centre) was the last major railway station to be built in the city in 1880. It was modelled on St Pancras station in London with a wrought iron, segmental vaulted roof with a span of 210 feet and a 90-foot apex at its highest point.

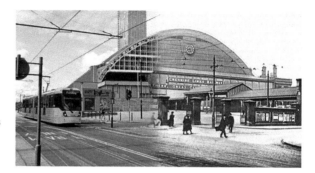

The concourse of the old Central Station has now been modernised and modern trams have replaced the steam and smoke of the old railway engines.

The Great Northern Warehouse and Deansgate Victorian Terrace

Built between 1895 and 1898, the Great Northern Warehouse dominates the eastern side of Deansgate. The innovative design and construction of the building made it an impressive road, rail and canal interchange. Built in Italianate style on the outside, the internal structure was notable for its use of steel pillars and cross-riveted steel beams that supported brick arches. The goods yard closed in 1963 and the warehouse is now a Grade II listed building.

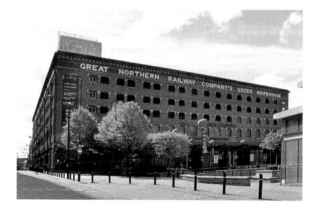

The Victorian façade along Deansgate was designed to hide the 'eyesore' of The Great Northern Warehouse from wealthy shoppers. It is possibly the longest terrace of its kind in the UK.

St John's Gardens

St John's Gardens mark the spot where St John's church and graveyard stood until 1931.

It is also noted on the monument that William Marsden is one of those buried in the gardens and that he originally came up with the Saturday Half-Day Holiday. In the 1800s, William sought to bring some respite for millworkers who worked long hours in poor conditions by campaigning for an early finish on Saturdays. Needless to say, his proposals were strongly resisted by the mill owners, who worried about losing money as their factories lay idle. Despite this, however, his campaign succeeded and workers in Manchester were the first in the country to finish work at 12 noon.

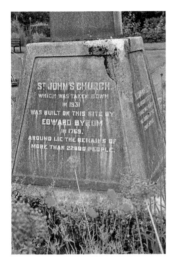

The monument in the centre of the garden gives a clear indication of the size of the local population as Manchester rose to become one of the world's great industrial cities. Over 2,000 people are still buried beneath the gardens.

Manchester Opera House

The Manchester Opera House in Quay Street opened as The New Theatre in 1912, but was renamed The Queens Theatre in 1915. Since 1920, it has been known as The Opera House. It has hosted a number of famous productions, including the regional premier of *Phantom of The Opera* between 1993 and 1995, and the European premier of *West Side Story* in 1958.

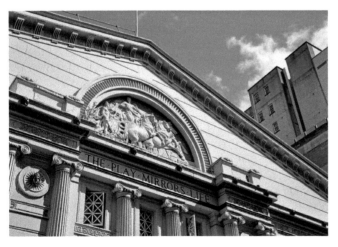

At the front of the theatre are three pairs of giant fluted Ionic columns, above which is the phrase, 'The Play Mirrors Life', topped by a bas-relief sculpture of *The Dawn Of The Heroic Age* by John Tanner and Son. The outer pair of columns contain pedestals with the names of actors.

The Beetham Tower and 'Cloud 23'

Wherever you go around the city centre, there's no escaping a view of The Beetham Tower. Designed by architect Ian Simpson, it rises 551 feet above Deansgate and is the tallest building outside London, and the fourth highest residential building in Europe.

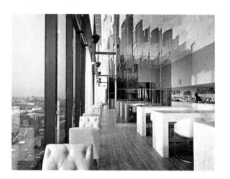

Cloud 23 is a very hospitable and welcoming place where you can enjoy anything from a simple coffee through to afternoon tea or a large selection of gourmet platters, while gazing to far horizons or watching the world rush by below.

Sitting on floor 23 is chic cocktail and champagne bar, Cloud 23, which offers unrivalled views across the Cheshire Plain to the south and the city, and the Pennines to the north. Visitors can access the bar via its own high-speed lift, which is situated in the foyer of the Hilton Hotel and whisks you non-stop from street level to a birds-eye view of the city. On a clear day, you can see Jodrell Bank, Snowdonia, Liverpool Cathedral and Blackpool Tower, as well as peering down onto the set of Coronation Street and Manchester's impressive Victorian skyline. Incredibly, it is visible from ten English counties. Whereas the location of the tower is no secret, this unique bar, tucked inconspicuously between the Hilton Hotel and Ian Simpson's penthouse, is something not to be missed on a visit to the city.

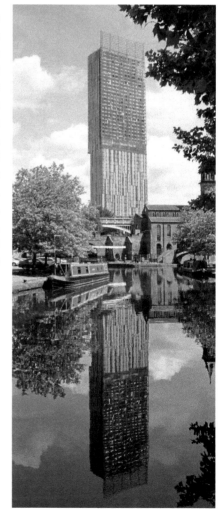

The forty-two-storey Beetham Tower dominates the skyline around the city centre.

2. AROUND ST ANN'S SQUARE

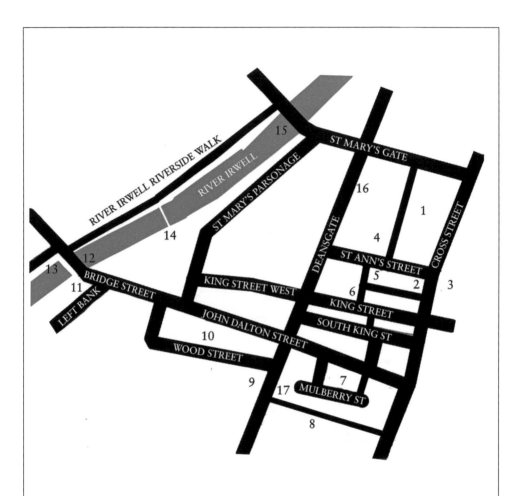

1 THE ROYAL EXCHANGE
2 MR THOMAS' CHOP HOUSE
3 CROSS ST UNITARIAN CHAPEL
4 ST ANN'S SQUARE
5 ST ANN'S CHURCH
6 ST ANN'S PASSAGE TO KING ST
7 THE HIDDEN GEM CHURCH
8 LINCOLN SQUARE
9 JOHN RYLANDS LIBRARY
10 WOOD STREET MISSION
11 PEOPLE'S HISTORY MUSEUM
12 ALBERT BRIDGE
13 THE MARK ADDY
14 TRINITY BRIDGE
15 BLACKFRIAR'S BRIDGE
16 BARTON ARCADE
17 CHOPIN'S STATUE

St Ann's Square was the first conservation area designated by Manchester City Council in 1979. There are many buildings in the area of significant architectural quality, with the majority being Edwardian or Victorian and, today St Ann's Square is the commercial heart of the city of Manchester.

Introduction to the St Ann's Area

The area on which the square is built was previously known as Acres Field and fairs were held regularly there over the centuries, with the farming communities of Lancashire and Cheshire gathering to attend markets that dealt in the sale of cattle, sheep, pigs and horses. The fields surrounding the square were generally common land over which the local villagers exercised their grazing rights. However, in the seventeenth century, as Manchester grew into a township, pressure was put on the area to redevelop.

St Ann's church was built in 1712 with a proviso that a space 30 yards wide should be reserved for the fair. During the following years, the square served as a place for hiring servants, and Bonnie Prince Charlie even reviewed his troops there in 1745. The fair was active in St Ann's Square until 1820, when it was moved to Shudehill, before eventually closing in 1876.

Narrow passages link St Ann's Square to other parts of the city and tollgates often controlled admission to the fair and other events. Today, you can still wander to King Street and John Dalton Street through the narrow passageways and Cross Street is accessed through the narrow St Ann's Alley.

The square has been home to the Manchester Cotton Exchange for over two centuries. The building, now known as the Royal Exchange, today houses the Royal Exchange Theatre, an impressive, tubular, seven-sided, steel structure suspended from four columns carrying the hall's central dome.

Nearby is Manchester's fashionable King Street, which contains the Old Exchange and the last surviving Georgian mansion in the city.

To the western side of the square is a small passageway leading to the Barton Arcade, which is the only surviving example of a Victorian shopping arcade in the city. A short distance along Deansgate is The John Rylands Library, which houses a number of impressive collections, including what is believed to be the oldest extant New Testament text.

The Royal Exchange

The building, which is today The Royal Exchange, is the fourth Exchange building to stand on this site being constructed between 1914 and 1921. Cotton trading took place in the great hall up until 1968.

The Exchange was given the title 'Royal' when the Queen visited Manchester in 1851. At the height of its trading business, up to 8,000 cotton traders could be found in its trading hall. However, with the decline of the cotton industry during the mid-twentieth century, there were only fifteen cotton mills left in the area when trading finally ceased in 1968.

The building was badly damaged in the Manchester Blitz when it took a direct hit at Christmas 1940 and was threatened with demolition. It was badly damaged again when an IRA bomb exploded in the city centre in 1996. The explosion caused the dome to move, but the structure of the building was undamaged. It was repaired and refurbished with the aid of £32 million of Lottery Funding, and was reopened by Prince Edward on 30 November 1998. The first production after the reopening was *Hindle Wakes*, the play that should have opened on the day of the bombing.

The theatre is a metal and glass structure, built in the style of an Elizabethan circular playhouse. It was conceived by Richard Negri of the Wimbledon School of Art. The weight of the structure is too great for the floor to bear and the module is suspended from four columns carrying the hall's central dome.

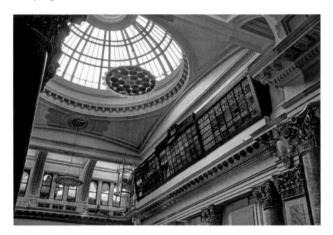

The trading board shows the final day's trading figures for December 1968.

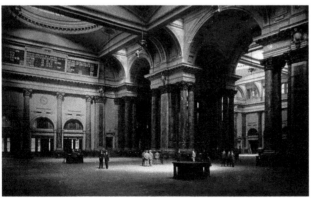

The inside of the Royal Exchange before the building of the theatre. The trading space was the centre for trading in the city at the height of the cotton boom.

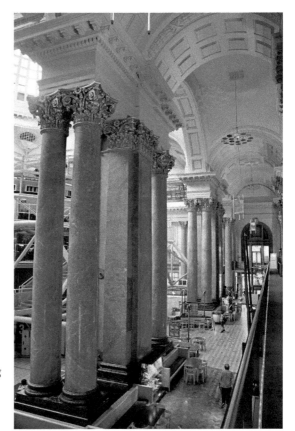

Right: Not all the pillars in the Royal Exchange Hall are real. The huge square ones holding up the theatre do their job admirably, but the smaller rounded pillars have no structural significance. They are made from an Italian material called scagliola, which is rolled out and bonded to the cement. Look closely to see the joins and tap firmly to hear the hollow sound.

Below: An inscription around the middle dome reminds us of the Exchange's trading roots. It was placed there to encourage honesty between the cotton traders and reads, 'Who seek to find eternal treasure must use no guile in weight or measure.'

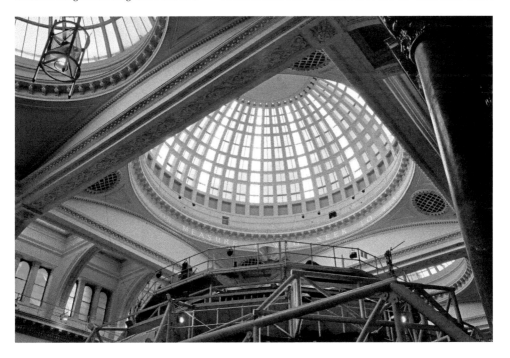

St Ann's Church

At the head of St Ann's Square sits St Ann's church. Lady Anne Bland, daughter of the Mosley family, gained permission from Parliament to erect a new church in Acres Field, which is now the area covered by St Ann's Square. She laid the cornerstone in 1709 and 1712.

Walk into the church from St Ann's Square. As you look towards the knave from the back of the church, the last stained glass window on your left is markedly different to the other Victorian glasswork that lines both sides of the aisle. The reason for this is that it has not been in the church for long and actually came from St John's church, once situated nearby. The window is the work of William Peckitt from York; a master of the art of stained and painted glass.

St Ann's has had a long tradition of flower arranging and, although the church is always bare of flowers during Lent, from Easter onwards, visitors will find a garden arrangement around the pulpit symbolising the garden from which Jesus rose from the dead.

 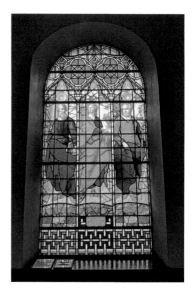

Above left: The church was consecrated and dedicated to St Anne. Lady Ann was a strong supporter of the Whigs and objected to the pro-Jacobite sermons being delivered in the Collegiate church (now Manchester Cathedral) on the other side of the city. Lady Ann and her associates became instrumental in turning the area around St Ann's into a fashionable commercial and residential area for the wealthy Manchester classes.

Above middle: An interesting feature on the outside wall is a carved ordnance survey bench mark, which can be found in one of the newly restored pieces of stone by the west corner. These marks were placed on buildings to accurately record distances between the centres of towns and cities. They were usually placed on post offices, but when the one inside the Royal Exchange closed, it was designated to appear on the nearest public building, which was St Ann's.

Above right: The exact date of the window's arrival is unclear, but we do know it was modified by Peter Gibson of the York Glaziers Trust – an organisation that successfully saved York Minster's famous Rose Window after the disastrous fire in 1984.

Mr Thomas' Chop House

Situated between the calm and tranquillity of St Ann's
churchyard and the busy commercialism of Cross Street, Mr
Thomas' Chop House is almost hidden away from casual
observer, squeezed into St Ann's Alley by the larger buildings
that rise above it on either side. It was redesigned and extended
by architect Robert Walker in 1901, and was one of the first
Manchester buildings to be constructed on a cast-iron frame.

Chop houses were originally places where Manchester
business people would meet and discuss their affairs in cosy
surroundings fortified by generous plates of cooked meats
and bottles of fine wine or traditional local beers.

Take a look inside, and you will discover an interior that is
almost totally original with impressive arches and Victorian
tiling. There have been thirty innkeepers associated with
these premises, and their names are listed in the back room as
a way of permanently recording their contribution to life in
the city centre.

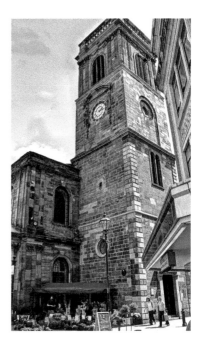

Top right: Outside the church, by the north porch, is the flower stall
that has been owned by the Fitzgerald family since 1895.

Bottom right: The exterior of Mr Thomas' Chop House consists
of a mixture of decorative terracotta blocks and Accrington brick.
The rear entrance from the back of St Ann's church is flanked by
the old stone posts, which originally indicated the boundary of
the graveyard.

Below: The current landlord, a talented photographer, has included
his own exhibition of black and white photographs of northern
personalities, which are mounted on the walls along the restaurant
and bar.

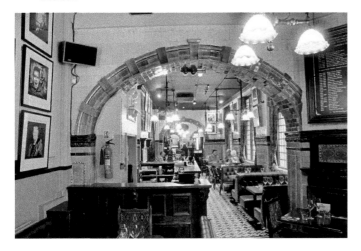

Cross Street Unitarian Chapel – Elizabeth Gaskell and Beatrix Potter

One of the chapel's longest serving ministers (1828–84) was the Revd William Gaskell, who, like all Unitarian ministers, was active in social work and providing a practical ministry for the poor. He was supported in his work by his wife and novelist, Elizabeth, and his congregation stood firmly behind issues raised in her books *Mary Barton*, *Ruth* and *The Life of Charlotte Bronte*, despite the text raising challenges to some conventional Victorial values. Elizabeth was brought up in the Cheshire Town of Knutsford, which became Cranford in her famous novel of that name. She developed literary associations in the city as Edmund Potter was a staunch Unitarian who had made his fortune through the expanding cotton trade. William was tutor to Edmund's son, Rupert, and when Beatrix was born to Rupert and his wife, Helen, William became a grandfather-like figure to her.

The chapel retains a collection of Elizabeth Gaskell's works, and The John Rylands Library has a collection of her manuscripts and first editions. Much of Elizabeth's work was centred around mill life in Manchester, which shocked her and inspired her writing, and Moss Side – then a rural farming community with open fields – was the inspiration for her book, *Mary Barton*.

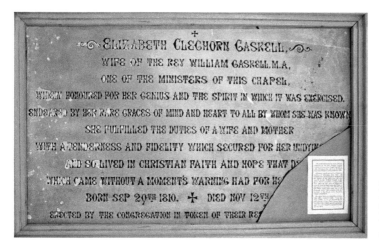

A memorial plaque to Elizabeth Gaskell sits just inside the entrance to the chapel on Cross Street.

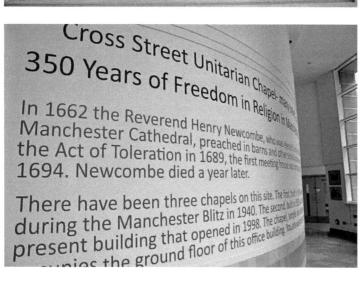

Today the chapel is situated on the ground floor of an office block, but still warmly welcomes visitors and worshippers.

Richard Cobden

At the head of St Ann's church stands the statue of one of Manchester's most influential men of the Victorian era. Richard Cobden was born in West Sussex in 1804, and spent much of his life in poverty before eventually making his first visit to Manchester in 1825, where he worked as a commercial traveller. By 1832, he ran a successful calico printing business and was living on Quay Street.

Cobden was an influentrial figure in Manchester life and instrumental in the foundation of the Athenaeum. He led Manchester's campaign against the Corn Laws, founding the Anti-Corn League, and was also passionate about the abolition of slavery. In his roles as MP for Stockport and the West Riding of Yorkshire, he made many anti-slavery speeches in Parliament. He died on the 2 April 1865, a week before the Confederate Surrender and twelve days before the assassination of Abraham Lincoln.

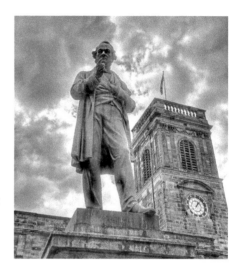

Having journeyed the world and developed an interest in history, commerce and foreign affairs, Cobden became a fierce opponent of social injustice and wrote regularly on such matters for the *Manchester Times* under the pseudonym of Libra.

St Ann's Passage and King Street

St Ane's Passage is a narrow entry that links St Ann's Square with fashionable King Street. St Ann's Square and King Street were high-class residential areas in Georgian Manchester, and maps from the 1740s show both as having terraced and detached houses with tree-lined roadways.

Only King Street retains any evidence of these Georgian dwellings, with Nos 35–37 being the best example, with much of its original façade intact. It was built in 1736 for Dr Peter Waring, but became a bank in 1772 – a usage it retained up until the 1990s. King Street was the first city centre street to be given over to pedestrian use in 1976.

The Hidden Gem Church

The Hidden Gem church can be found by taking the narrow passage opposite St Ann's Passage on King Street, and crossing John Dalton Street into another narrow entry that brings you into Mulberry Street.

The Hidden Gem is the oldest post-Reformation Catholic church in any major town or city in England, and contains some significant works of art, including Norman Adams' *Stations of the Cross* (1994), which are arranged along the interior side wall and of national importance. Its name originates from a visit to the church in 1872 by the Catholic Bishop of Salford, Herbert Vaughen, who, when commenting on its elaborate interior decoration, said, 'No matter what side of the church you look, you behold a hidden gem.'

Lincoln Square and Abraham Lincoln's Statue

Walking through the passage opposite The Hidden Gem brings you into Lincoln Square, set in a pedestrianised walkway linking Albert Square with Deansgate. In the centre of the square is George Grey Bernhard's bronze sculpture of Abraham Lincoln, which should originally have stood outside the Houses of Parliament in London, but was deemed too unstatesmanlike to occupy such a prominent position. Manchester laid claim to the statue by arguing that strong links had been established with America through sacrifices made by cotton workers in support of the Union, resulting in the abolition of slavery during the American Civil War – a sacrifice Lincoln acknowledged himself.

 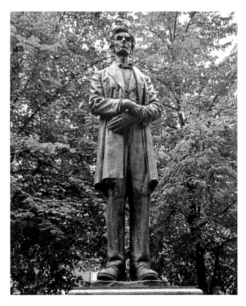

Above left: The church of St Mary was built between Deansgate and Albert Square in 1792, at a time when poverty and destitution were a normal part of life in the city. The spire of the church is based on a medieval Gothic design.

Above right: Abraham Lincoln's statue was granted to Manchester and erected in Platt Fields in 1919. Its unveiling was a marked celebration of Manchester's liberal values, supporting the sacrifices made by workers during the cotton famine. It was moved in 1986 to become the focal point of the new public space in the centre of the city.

John Rylands Library

John Rylands Library sits on Deansgate on the edge of Spinningfields Square. It is a masterpiece of Victorian Gothic architecture. Enriqueta Rylands commissioned the library as a memorial to her husband, John, who died in 1880. John was one of Manchester's most successful industrialists and left a personal fortune of around £2.75 million on his death. After his death, Enriqueta added two more collections of private books to his personal collection, which made it one of the leading scholarly libraries in the country. The impressive collection includes the oldest known piece of the New Testament – the St John Fragment. There are also rare, illuminated medieval manuscripts and an edition of *Canterbury Tales* printed by William Caxton, which dates from 1476.

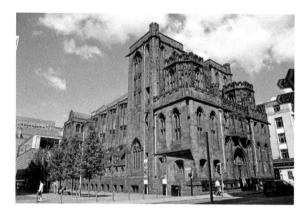

In 1872, the library became part of The University of Manchester and currently holds special collections of books and other archive material belonging to the university.

The Working Men's Church and Salford Street Children's Mission

Just to the side of John Rylands Library in Wood Street is the location of the Wood Street Mission. It was founded in 1869 by Methodist minister Alfred Alsop, who wanted to alleviate the effects of poverty on children and families in Manchester and Salford. A further development of the Working Men's church, a little further along in Bridge Street, supported the work of the Mission.

Clothes and shoes were handed out as well as presents each Christmas. In the 1880s, the Mission ran day trips to Southport, which proved so successful that a seaside camp was built to accommodate around 120 children for holidays. At the end of the First World War, the Southport camp was replaced by one at Blackpool, which was much larger and based at Squires Gate. The Blackpool home was closed in 1963 and replaced by an outdoor pursuits centre in Derbyshire. The work of the Mission has continued into the twenty-first century, distributing clothes, toys bedding and baby equipment to families in the city, continuing its fight against poverty that has lasted nearly 150 years.

The Mission operated in some of the worst slums around Deansgate and provided a soup kitchen and night accommodation for neglected boys.

The People's History Museum

The People's History Museum is situated on Bridge Street, just before Albert Bridge crosses The Irwell. Formally known as The National Museum of Labour History, it is a national centre for the collection, interpretation, and study of material relating to the history of working people in Britain.

The museum houses important archive material relating to the social history of Britain and includes papers and documents created by the Labour Party, the former Communist Party of Great Britain, the co-operative movement and the Department For Work and Pensions. There is also coverage of much of the city's history, including the rise of nineteenth-century trade unionism, the Women's Suffrage Movement and the Peterloo Massacre.

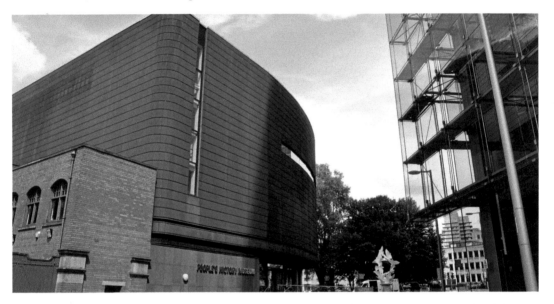

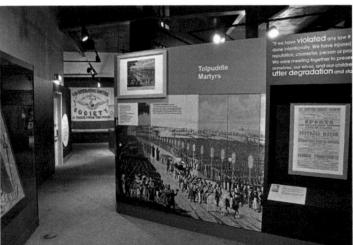
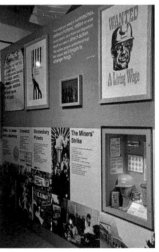

The museum is packed with archive material and stories relating to the social and political class struggles of the past two centuries. The building was designed by architect Henry Price, and is a former hydraulic pumping station that is now Grade II listed.

Albert Bridge, Trinity Bridge, Blackfriars Bridge and The River Irwell

Just outside the People's History Museum, Albert Bridge connects the city of Manchester with the city of Salford. It was constructed in 1843 at a cost of around £9,000. The first vehicle to cross after its opening was a donkey and cart from Manchester. The bridge replaced New Bailey Bridge, which was a toll crossing designed to recoup the money off shareholders who had bought £40 shares to facilitate its construction in 1785.

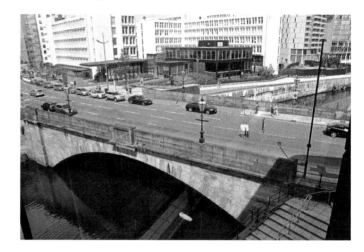

Albert Bridge is approximately 60-feet wide and uses a skew arch of approximately 111 feet to cross the river. It was declared a Grade II listed building on 20 June 1988.

The River Irwell

The River Irwell marks the border between Manchester and Salford, travelling some thirty-nine miles from the Lancashire Moors before joining with the Manchester Ship Canal at Irwell. Until the early nineteenth century, it was well stocked with wildlife, and people living near the cathedral would use its water for drinking and bathing. However, with the rise of industrialisation, large quantities of gas tar, gas lime and ammonia water were discharged into the river, resulting in Scottish geologist Hugh Miller describing the river as 'a flood of liquid manure, in which all life dies, whether animal or vegetable, and which resembles nothing in nature, except, perhaps, the stream thrown out in eruption by some mud volcano'.

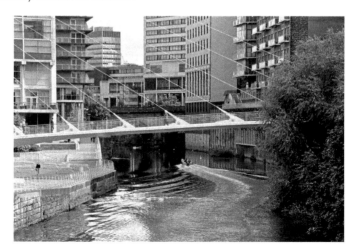

The River Irwell forms a natural barrier between the cities of Salford and Manchester. It was a navigable river during the early years of Manchester's development and its banks would have been lined with factories and mills, causing the heavy pollution that blighted the river.

Mark Addy

Mark Addy's association with the river during the mid-to-late-nineteenth century has gone down in Manchester folklore. He was born in a tenement at Stage Buildings near Blackfriars Bridge in 1838, where his father and uncle were boatbuilders. His famous rescues began when he was only thirteen, and he was awarded a number of gold and silver medals from the Humane Society for the Hundred of Salford. In 1878, he became the only civilian to be awarded the Albert medal (first class) which was presented to him by Queen Victoria.

His final rescue, of a young boy who had fallen into a particularly nasty, sewage-laden stretch of the river, came on Whit Monday in 1889. However, this resulted in him falling ill with tuberculosis and he died the following year, aged fifty-one. During his life, he had rescued over fifty people from the river.

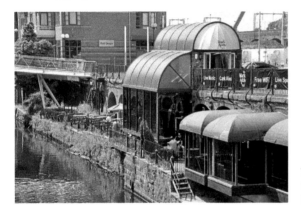

The Mark Addy pub on the banks of the river near Albert Bridge is a permanent reminder of Mark's heroics.

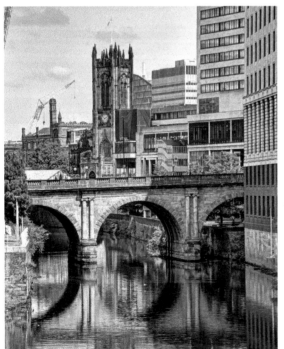

Blackfriar's Bridge

Passing Trinity Bridge, which was designed by Spanish architect Santiago Calatrava, you arrive at Blackfriars Bridge, which was built in 1820 and uses three sandstone arches to cross the river. It replaced the old wooden structure, which was built by a company of comedians to allow people to cross to the Riding School in Salford where they performed.

The new Blackfriars Bridge was originally a toll crossing and there was a competition held for its design which was won by Thomas Wright of Salford, who was awarded the first prize of £150.

Barton Arcade

Turning right into Deasgate from Blackfriar's Street, a short walk takes you to the entrance of Barton Arcade, a Victorian shopping arcade that links Deansgate to St Ann's Square. The building was constructed by Corbett, Raby and Sawyer in 1821 and has had Grade II listed status since 1973. The iron work was supplied by the MacFarlane Saracen Glass Factory in Glasgow. It has been suggested that the building lends its Italianate flavour to the influence of the Galleria Vittorio Emanuele in Milan.

Manchester and Fryderyk Chopin

On Monday 28 August 1848, at the Gentlemen's Concert Hall at the corner of Peter Street and Lower Mosely Street, a gravely ill Fryderyk Chopin insisted on performing a gala concert to an audience of 1,200 Mancunians. In 2011, to just after the bi-centenary of his birth, a statue was unveiled on Deansgate to celebrate, not only Chopin's life, but the special relationship between the people of the North West and the many Polish people who had settled in the area during the years of upheaval in the twentieth century.

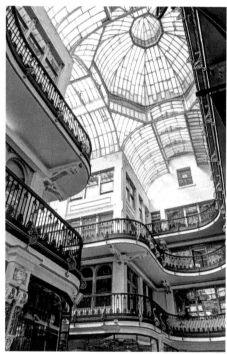

Above: Chopin's statue, by Robert Sobocinski, stands on Deansgate opposite the John Ryland's Library. He died from the complications of tubercolosis in Paris in 1849, at the age of thirty-nine.

Right: Barton Arcade is an impressive structure of glass and ironwork topped by glass domes. It was one of the first buildings to be constructed on the newly widened Deansgate. However, the original shop fronts and decorative floor no longer exist.

3. AROUND THE CATHEDRAL AREA

1 VICTORIA STATION
2 CHETHAM'S SCHOOL OF MUSIC
3 MANCHESTER GRAMMAR SCHOOL SITE
4 CHETHAM'S LIBRARY
5 MANCHESTER CATHEDRAL
6 THOMAS MINSHULL'S HOUSE
7 HANGING DITCH
8 THE SHAMBLES
9 THE CORN EXCHANGE
10 THE NATIONAL FOOTBALL MUSEUM
11 THE PRINTWORKS
12 CORPORATION STREET POST BOX

Introduction to the Cathedral Area

Manchester's cathedral area has been a scholarly and ecclesiastical centre for Manchester since early times.

The buildings that form around the cathedral cluster in a medieval street pattern bounded on the outside by the curving line of Cateaton Street, Hanging Ditch, Todd Street, Victoria Station and Hunts Bank. To the southwest, the cathedral is separated from the rest of the city by a curve of Victorian buildings, including the Corn Exchange. To the north and west, the cathedral overlooks busy Victoria Street and the deep running River Irwell.

The area was designated a conservation area in April 1972 to maintain the quality and uniqueness of the setting for the cathedral and Chetham's Hospital School.

The cathedral has been subject to much rebuilding over the years and was extensively reconstructed and enlarged following the creation of the Manchester Diocese in 1847, and during its elevation to cathedral status. The nave itself holds the distinction of being the widest in England, some 10 feet wider than York Minster.

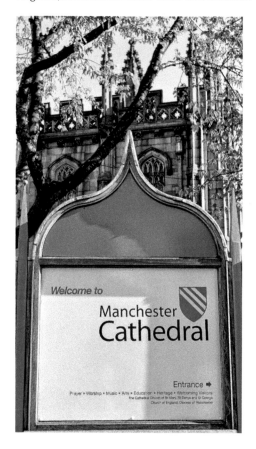 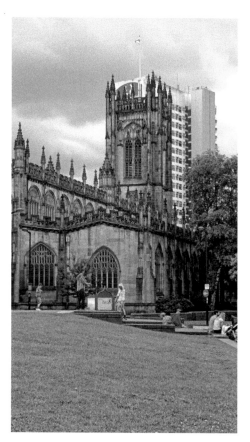

Above left: A warm welcome awaits you at Manchester Cathedral. It is a vibrant, inclusive worshipping community. Concerts and exhibitions are held on a regular basis.

Above right: The green space of Cathedral Gardens has recently been redeveloped. The Cathedral, Chetham's School of Music, the Urbis building and the Corn Exchange can all be seen from this point.

The present Chetham's School was founded in 1656 and stands on the site of the Manor House of the Barony of Manchester where, in the twelfth and thirteenth centuries, court meetings were held by the judicial body responsible for governing the medieval town. Today, it is a nationally known music school, with a library that contains over 70,000 books.

Across the green, open space of cathedral gardens sit two more contemporary attractions – the National Football Museum opened in 2012 and is sited in the modernistic glass construction of the Urbis building. Behind, at the junction of Corporation Street and Withy Grove, is The Printworks. Today, it is a maze of modern shops, bars and cafes, but previously it was the centre of Manchester's *Evening Chronicle, The Daily Mirror* and other publications that rolled off the presses between 1873 and 1985.

To the south of Cathedral Gardens, the Corn Exchange is known universally as The Triangle. A grocery and provision market has been present on the site of the Corn Exchange since medieval times, with a permanent building being erected in Hanging Ditch in 1837. The present building took thirteen years to construct and was completed in 1903. It was previously named The Corn and Produce Exchange and, before it was badly damaged in the IRA bombing of 1996, was a warren of craft stalls and small shops. Today, it is undergoing refurbishment, taking it back to its roots with an emphasis on food outlets and food market stalls.

The Printworks sits between the glass construction of the Urbis building and the Corn Exchange.

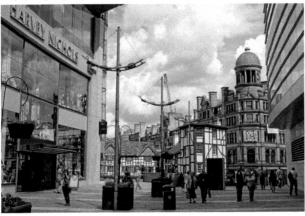

Manchester's modern shopping area enhances the historical medieval and Victorian buildings.

Victoria Station

Victoria Station has been one of the largest passenger stations in Britain since it was built in 1844. The original single-storey building, with a long single platform, was designed by George Stephenson and completed by John Brogden. Although it is currently undergoing a refurbishment programme, the station has retained a traditional look with the old wood-panelled booking office still in operation and the original tiled wall still displaying the company's routes across Lancashire and Yorkshire. The original wrought-iron and glass canopy can be seen outside on Victoria Station Approach.

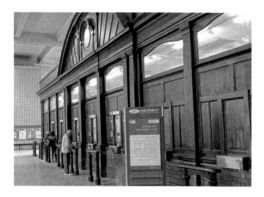

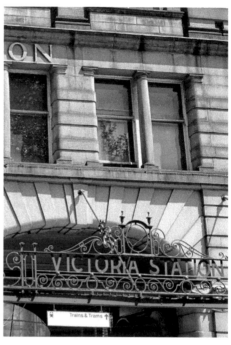

Above: The traditional Victorian booking office is still in operation and serves the thousands of travellers using the station.

Right: The elaborate façade of the station with the wrought iron and glass canopy.

Below: Victorian travellers could check their destination and route by looking at the map on the tiled wall.

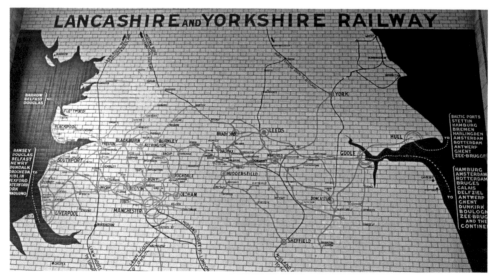

Chetham's School of Music

Chetham's, a world-class school of music, is the largest specialist music school in the North of England. It was founded in 1969. However, the oldest parts of the school are nearly 600 years old, built in 1421 to accommodate the priests of Manchester's Collegiate church. These are now listed buildings. The Victorian Palatine Building, the former music department, was replaced in 2012, and a new concert hall was built. Access to the grounds and building is not permitted, as this is a school. However, Chetham's students perform daily during the school term. The young musicians show their outstanding qualities when playing in the medieval Baronial Hall and the new twenty-first-century Carole Nash Hall. Both settings are awe-inspiring.

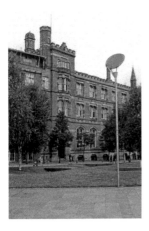

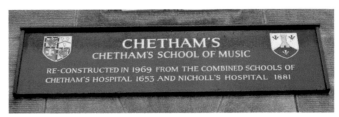

Left: The area in front of the school has recently been redeveloped. City Park is an extension of the cathedral gardens and consists of lawns, earth sculpture, extensive tree planting, art installations and a water feature.

Above: The plaque indicates Chetham's School of Music is now situated on the site of Chetham's Hospital, 1653, and Nicholl's Hospital, 1881.

Manchester Grammar School

A plaque now marks the original site of Manchester Grammar School on which, for more than four centuries, successive generations of boys were educated. The school was founded in 1515 by Hugh Oldham, Bishop of Exeter, and remained here until 1931 when the school was transferred to its present site at Rusholme. This 'new' building, The Manchester Grammar School Extension, was built in the 1870s. It was designed by Alfred Waterhouse and included new classrooms, a gym and science laboratories.

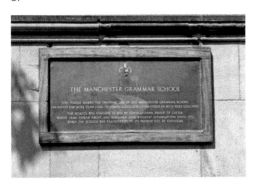

Above left: The plaque indicating the original site of the school.

Above right: The building, renamed the Long Millgate Building, was used as a teacher training college from the 1950s until its closure in 1978. Chetham's School of Music then took over the premises.

Chetham's Library

The library, which was founded in 1653, is the oldest surviving public library in Britain, being established under the will of Humphrey Chetham (a prosperous Manchester textile merchant, banker and landowner). The acquisition of books began in 1655 and the library has been adding to the collection ever since. The collection includes early printed books, a wealth of ephemera, manuscript diaries, letters and deeds, prints, paintings and glass lantern slides. Chetham's Library is open to visitors, but an appointment is required if you wish to read.

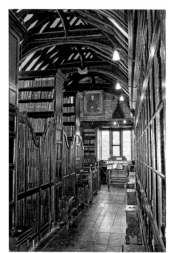

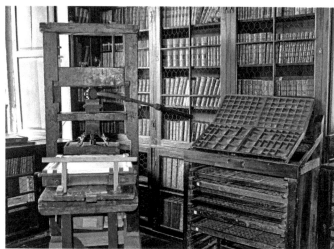

Above left: The priests' wing is housed on the first floor of the library.

Above right: The old library printing press.

Right: The pump in the west wing of the medieval doubled-storeyed cloisters.

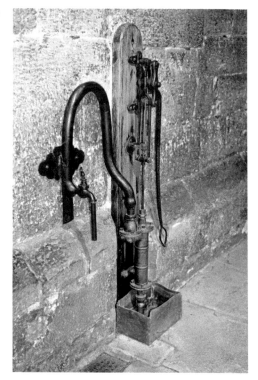

Manchester Cathedral

Manchester Cathedral is a Church of England cathedral, and a building rich in spirituality and history. Most of the stonework was restored in the mid-nineteenth century. This is why, although the design is fifteenth century, much of the cathedral's outward appearance is Victorian. It is beyond the scope of the book to mention its extensive history, however, some of the fabric of the tower predates 1421 and it is estimated the tower arch is 800 years old. Within the tower is the bell chamber with ten bells, which are rung regularly.

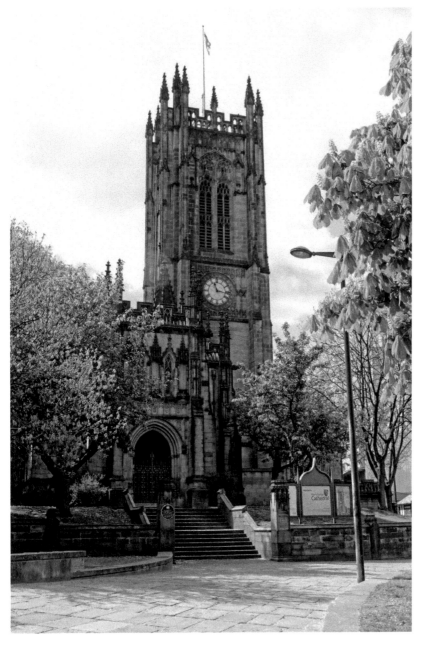

The de Gresle family, who were Norman barons of Manchester, built a fortified manor house on the site of the present Chetham's School of Music next to a small Middle Ages church. The de Gresle shield is used, to this day, as the cathedral crest. In 1421, Thomas de la Warre obtained licences to found a new collegiate church. The rebuilding of the church took 100 years to complete.

Manchester Cathedral

The Fire Window was installed in 1966 and is a stained-glass representation of flames that now serves to commemorate the two twentieth-century bombs that badly damaged the cathedral; the magnificent early sixteenth-century choir stalls contain some of the finest carving of its kind in Europe. Warden Dr John Dee (1527–1608) was regularly consulted by Queen Elizabeth I and he travelled widely in Central Europe, writing many reports about the places he visited for her. He always authenticated his signature with the code 007 and, on a visit to the cathedral, Ian Fleming, the creator of James Bond, adopted the formula. Take time to walk around and find out about the Consort of Angels, the Nineteenth-Century Mistake, The Cathedral, the Fraser Chapel and the golden Lancashire Madonna to name a few of its gems.

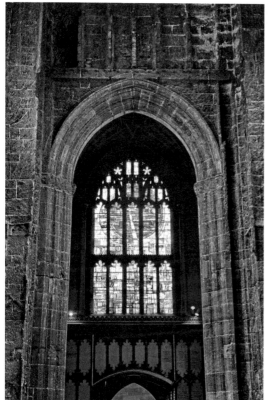 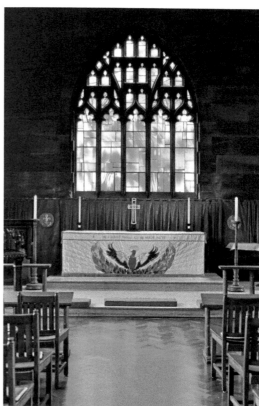

Above left: The Tower Arch is estimated to be 800 years old.

Above right: The Fire Window, positioned at the eastern end of the Regiment chapel, installed in 1966, is a stained-glass representation of roaring flames.

Hanging Ditch Bridge

The bridge was originally built in 1343 to span the Hanging Ditch, an improved natural watercourse leading past St Mary's church, as the cathedral was then, to join the River Irwell. The excavated remains of the medieval Hanging Ditch Bridge are visible between Cathedral Yard and Cateaton Street, and are also incorporated in the basement of the Cathedral Centre. The ditch was part of the defences of the medieval town and the bridge connected the road from Chester with the town centre. The original bridge was a removable wooden bridge that was suspended over the ditch.

Left: The excavated remains of the medieval Hanging Ditch Bridge.

Thomas Mynshull's House

The building of red sandstone with moulded terracotta is dated 1890, and is Grade II* listed. It is purported to be the site of the house of the apothecary Thomas Mynshull, who died in 1689. The inscription on the front reads: 'Thomas Mynshull sometime apothecary of the town bequeathed this property to trustees to apprentice poor sound & healthy boys of Manchester in honest labor & employment.'

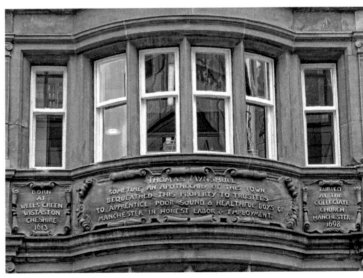

Above left: Thomas Mynshull's House is an elaborate and ornate red sandstone building.

Above right: The gold painted inscription can be clearly seen on the house.

The Shambles

The buildings date back to the seventeenth century. They were originally located in a street of medieval buildings known as the Shambles, close to Market Place. The Shambles survived the blitz during the Second World War. The Old Wellington and Sinclair's Oyster Bar have been moved twice, once during the 1990s and again after the 1996 bombing. They were originally adjacent, but, in this new location, they have been re-oriented in an L-shape. Sinclair's was renamed as Sinclair's Oyster Bar when oysters were added to the menu in 1845.

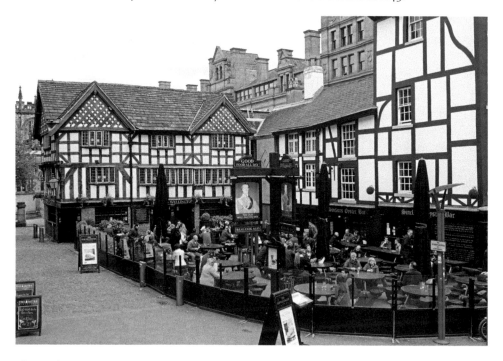

Above: The two seventeenth-century buildings have been moved twice. The Old Wellington Inn dates back to 1552, when it was a private residence and part draper's shop. It was licensed in 1862 as the Vintners Arms. It later became the Kenyon Vaults, and finally the Old Wellington Inn.

Right: Sinclair's Oyster Bar was originally called John Shaw's Punch House. By law, closing time during the eighteenth century was 8 o'clock. John Shaw, master of the house, would crack a whip to ask the gentlemen to leave. Shaw's maid, Molly Owen, would throw a bucket of water over them if the customers did not go; hence the sign shows Molly holding a watch showing 8 o'clock.

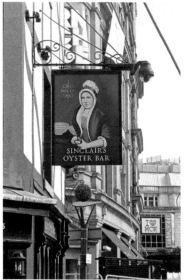

Corn Exchange

Corn and produce has been exchanged on the site since medieval times. A permanent building was erected in 1837. The present building, now Grade II* listed, took thirteen years to construct and was completed in 1903. The Corn Exchange is known as The Triangle because of its shape. It is currently undergoing refurbishment and plans to re-open with a variety of food stalls and outlets.

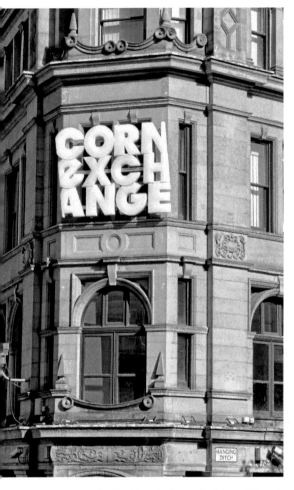 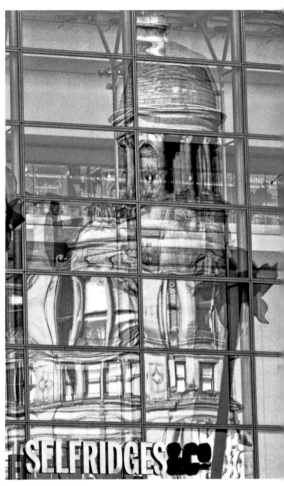

Above left: The Corn Exchange building at Hanging Ditch.

Above right: A reflection of the Corn Exchange in the glass frontage of Selfridges & Co.

The National Football Museum

The National Football Museum opened in 2001 in Preston. In 2011, thanks to funding from Manchester City Council, the museum set up its new home in the Urbis building here in the city. It opened to the public on 6 July 2012. This unique museum brings the history of the 'beautiful game' to life across four floors. The museum displays world-famous football memorabilia as well as incorporating some fantastic interactive galleries.

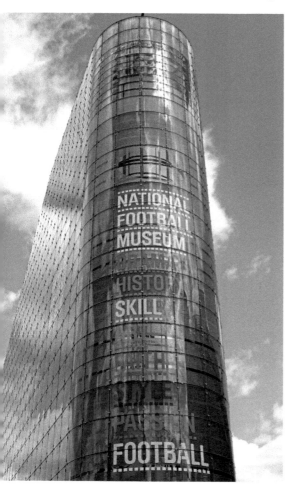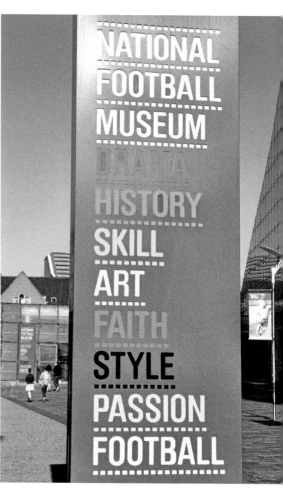

Above left: The modernistic glass construction of the Urbis building reflecting the ever changing skies above Manchester.

Above right: A description of what the visitor to the museum will encounter.

Printworks

The past history of the Manchester newspaper business is represented both on the inside and outside of the Printworks building. For example, parts of the newspaper railway system have been incorporated in the floor. The Printworks is now an entertainment venue that houses a nightclub, restaurants, a fitness club and a multi-screen cinema.

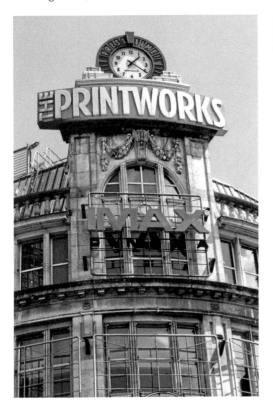
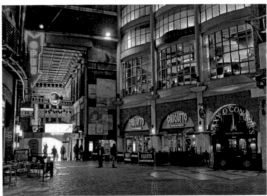
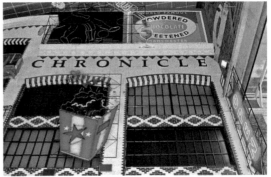

Left: The Printworks building stands proud at the junction of Corporation Street and Withy Grove.

Top right: The old and new sit and fit together well in an atmospheric environment.

Bottom right: The history of the newspaper industry is found within the Printworks.

Corporation Street Postbox

The street just outside the Arndale Centre and the surrounding area were obliterated when a bomb exploded at 11.10 a.m. on 15 June 1996. There was widespread damage and most of the buildings were devastated. A postbox, dating back to 1887, was all that stood among the chaos. It was removed while the area was rebuilt, but was reinstated bearing a brass plaque that reads, 'This post box remained standing almost undamaged on 15th June 1996 when this area was devastated by a bomb. The box was removed during the rebuilding of the city centre and was returned to its original site on 22nd November 1999.

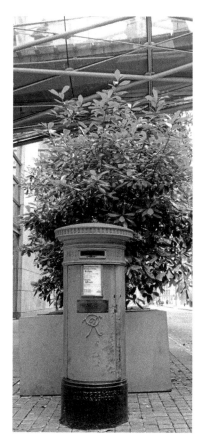

Right: The Postbox on Corporation Street remained intact following the Manchester bomb on 15 June 1996.

Below: The footbridge across Corporation Street links the Arndale Centre to the building that houses Selfridges and Marks & Spencer. It was built in 1999 by Hodder Associates and Ove Arup. According to the architect, the footbridge 'takes the form of a hyperbolic paraboloid of revolution and appears as a lightweight glazed membrane'.

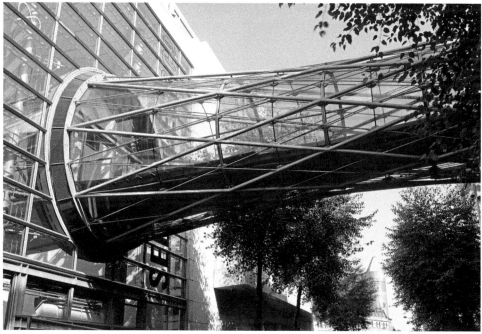

4. AROUND THE NORTHERN QUARTER

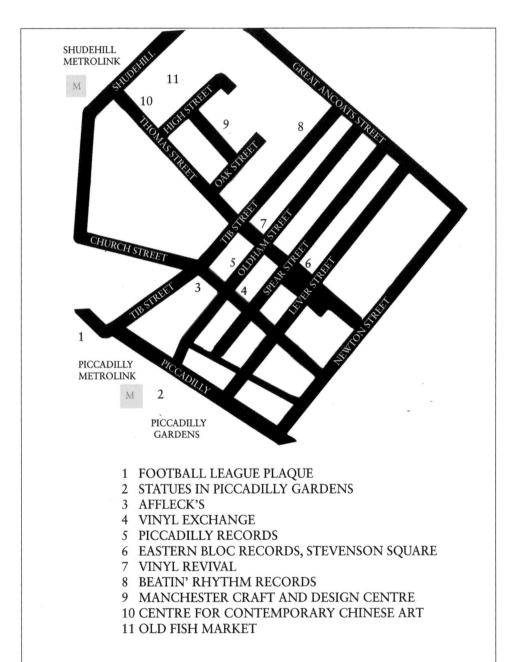

1 FOOTBALL LEAGUE PLAQUE
2 STATUES IN PICCADILLY GARDENS
3 AFFLECK'S
4 VINYL EXCHANGE
5 PICCADILLY RECORDS
6 EASTERN BLOC RECORDS, STEVENSON SQUARE
7 VINYL REVIVAL
8 BEATIN' RHYTHM RECORDS
9 MANCHESTER CRAFT AND DESIGN CENTRE
10 CENTRE FOR CONTEMPORARY CHINESE ART
11 OLD FISH MARKET

Introduction to the Northern Quarter

The Northern Quarter journey starts just outside of its boundary in Piccadilly Gardens. The area has gone through a number of changes over the years, and the more recent programme of works is breathing new life into the gardens. A new playground, which includes a synthetic surface and a range of play equipment, has been built. The Wheel of Manchester, a 52.7-metre high Ferris wheel, is now also based in the gardens. The history of the area can easily be seen by standing and looking around at the many Grade II* listed buildings and statues.

The Northern Quarter itself is an area within the northern part of the central city. It lies within Oldham Street, Swan Street, Shude Hill, Withy Grove and High Street. The area has been going through regeneration since the 1990s and is now a lively and vibrant part of the city. The many bars and restaurants, as well as the music and clothes shops, define its alternative and bohemian culture, which has quickly become the most popular place to go for a day's shopping, followed by a good night out.

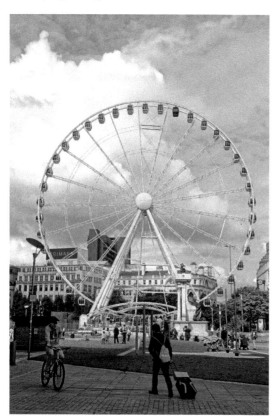
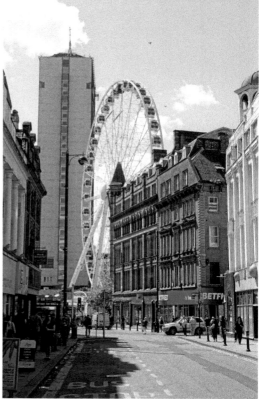

Above left: Piccadilly Gardens is an area that's always on the go. The view shows the new playground and the Wheel of Manchester.

Above right: Oldham Street looking towards Piccadilly Gardens. The nineteenth-century Victorian buildings contrast against the new constructions of the twenty-first century.

The Northern Quarter is steeped in history from the time it was a village between Shude Hill and Victoria Station in the fourteenth century, through to the Industrial Revolution, as Manchester became the world capital of the textile industry; the Cottonopolis Era. Many well-known people have helped develop the area, including John Welsey, who opened Methodist chapels, to Richard Arkwright, who opened Manchester's first cotton mill on Miller Street.

The Northern Quarter offers a diverse shopping experience, so whether you want to shop or just browse, relax with a coffee or soak up the atmosphere, it will certainly cater for the needs of all ages. Affleck's, a red-brick converted Victorian warehouse on Tib Street, is a classic example of this. Elaborate artwork adorns the outside of the building and the Tib Street Horn, by David Kemp, is close by. Music lovers will enjoy the area with shops such as Piccadilly Records, Vinyl Exchange, Vinyl Revival, Eastern Bloc Records and Beatin' Rhythym Records, and live music in venues, such as The Night and Day Cafe, Band on the Wall and The Ruby Lounge.

The area has become renowned for its creativity, from fashion design through film industry to the art galleries. The Manchester Craft and Design Centre, and the Centre for Chinese Contemporary Art have brought a variety of art and artists into the area.

The Northern Quarter was off-limits after dark in the past, but now it's one of the city's best places to be at night, and also during the daytime, with its fine blend of culture and cuisine.

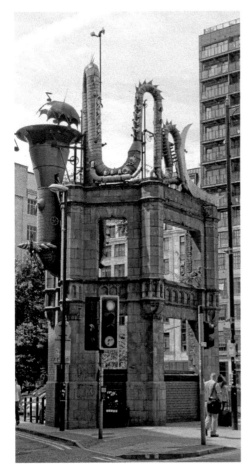

Left: Architectual gems can always be found when walking around the Northern Quarter, for example, the Tib Street Horn.

Below: Stevenson Square now houses a range of art shops, bars and cafés. The 'Square' has a rich commercial history where textile warehouses and wholesalers once operated.

The Football League Plaque

In 1888, William McGregor, director of Aston Villa, wrote to the committee members of Blackburn Rovers, Bolton Wanderers, Preston North End, Stoke FC and West Bromwich Albion. He suggested that they create a number of guaranteed fixtures each season for its members. An initial meeting was held at Anderton's Hotel, London, on 23 March 1888. However, it was at a further meeting on 17 April at the Royal Hotel, Manchester, that the Football League was created and formed. The twelve-member clubs, made up of teams from the Midlands and North of England, started the first season on 8 September 1888. The first team to become champions, 1888/89, was Preston North End. A red plaque shows the site of where the Royal Hotel once stood.

Right: The Royal Hotel once stood at the junction of Mosley Street and Market Street. The football league was formed at this venue on 17 April 1888.

Below: The red plaque indicates where the Football League was formed.

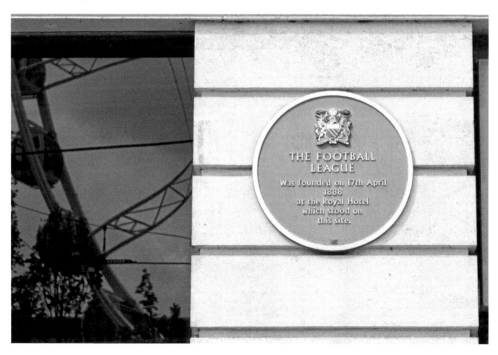

The Statues in Piccadilly Gardens

Piccadilly Gardens is the green area that lies between Market Street and the edge of the Northern Quarter. Many of the buildings that surround the gardens are Grade II* listed. In addition, the four main statues, which stand on what was the esplanade of the Manchester Royal Infirmary are also Grade II* listed.

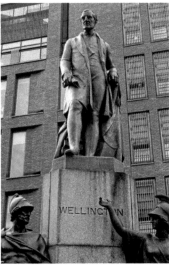
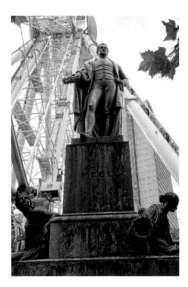

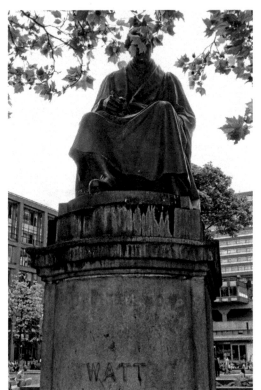

Above left: Queen Victoria, 1819–1901, reigned for sixty-three years and seven months.

Above middle: The Duke of Wellington, 1788–1852, was one of our leading military and political figures of the nineteenth century.

Above right: Sir Robert Peel, 1788–1850, improved factory working conditions for women and children, and twice served as Prime Minister.

Left: James Watt, 1736–1819, was a Scottish inventor and mechanical engineer renowned for his improvements in steam engine technology.

Affleck's

Affleck's, formerly Affleck's Palace, is stated as 'an emporium of eclecticism, a totem of indie commerce in Manchester's Northern Quarter and, above all else a fantastic place to shop for anything from top hats to tattoos'. The indoor store houses a large number of independent markets that attract thousands of shoppers throughout the year. The red-brick Victorian building is decorated with artwork. The Silver Tree at the side of Affleck's was installed in 2011, and a notice by the main entrance reads: 'AND ON THE SIXTH DAY GOD CREATED MANchester'.

Above left: When you enter the Victorian red-brick building, you'll find a different shopping experience.

Above right: The Silver Tree adorns the side of the Affleck's building.

Right: The mosaic window makes a tongue-in-cheek statement.

Music in the Northern Quarter

Music has always been an integral part of Manchester's culture, incorporating the Elizabethan town waits, classical music from the two symphony orchestras, the Halle and the BBC Philharmonic, the traditional NW brass bands and, of course, pop music of the '60s and '70s. Manchester had a fantastic music scene during that time, with many groups emerging. The 'Madchester' music scene of the late '80s and early '90s brought media attention to the city.

The Northern Quarter is the heartbeat of the city's music. It offers a highly concentrated record shopping experience, while specialising in bringing live music, DJs, music events and exhibitions in the area. Whether you are trying to find a second-hand rarity or a hard to find gem, or you just want to browse, you'll enjoy the atmospheric musical experience and be spoilt for choice in the Northern Quarter.

Left: Eastern Bloc Records and cafe at No. 5A Stevenson Square. Established in 1985, Eastern Bloc Records has had a major influence on the Manchester music scene, especially during the '80s and '90s. Today, they provide the best in electronic music on vinyl with CDs and vinyl, specialising in drum and bass, jungle, dubstep, house and techno, with electronica also being available. Eastern Bloc also has a cafe.

Below: Vinyl Exchange at No. 18 Oldham Street. Established in 1988, Vinyl Exchange are specialists in collectable and rare dance vinyl, rare and deleted titled CDs, punk, disco and soul.

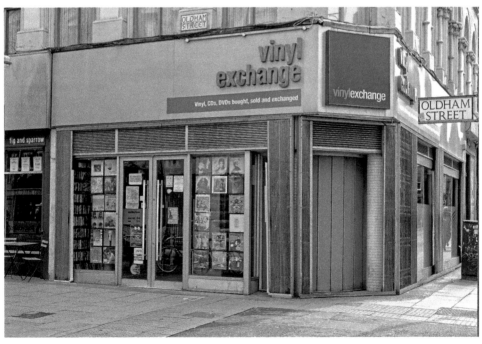

Music in the Northern Quarter

The music experience can be found in the many record shops, which lie only a short distance from each other. These include: Eastern Bloc Records, Piccadilly Records, Vinyl Exchange, Vinyl Revival and Beatin' Rhythm Records. If you are a discerning music fan or if you want to switch between mainstream and more diverse music, the span of genres can be found here.

The Northern Quarter also has a high proportion of live music venues including: Band on the Wall, Night and Day, The Ruby Lounge, Matt and Phreds, Dry Live and Twenty Twenty Two.

Piccadilly Records at No. 53 Oldham Street. Established in 1978, Piccadilly Records is an independent record shop where you will find a large choice of classic vinyl, the newest releases, and a vast selection of every music genre.

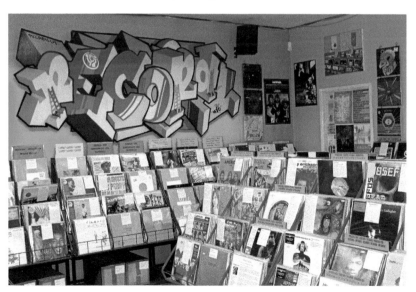

Inside Piccadilly Records.

Music in the Northern Quarter

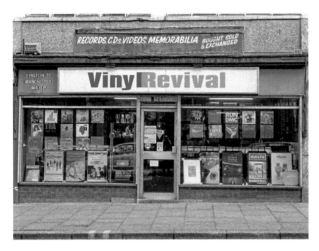

Vinyl Revival at No. 5 Hilton Street. Established in 1997, Vinyl Revival are specialists in the music of Manchester bands from the '60s to the present day, with vinyl, CDs, t-shirts and posters available. You will also find a vast selection of other music genres in store.

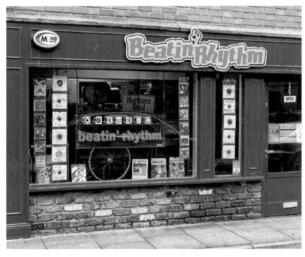

Beatin' Rhythm Records at No. 108 Tib Street. A great place for soul, rock 'n' roll, pop reissues, funk, doo-wop, girl group, rare soul, Northern Soul, surf, psych, rhythm 'n' blues and themes.

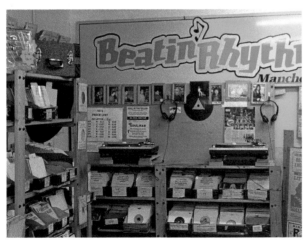

Inside Beatin' Rhythm Records, where you are encouraged to listen to music on the decks.

Manchester Craft and Design Centre

A former Victorian fish market building on Oak Street now houses the Manchester Craft and Design Centre. The large glass roof that once protected the old Smithfield market from the elements means that jewellery, ceramics and textiles (as well as shoppers), are always bathed in lovely light. There are eighteen working studio boutiques over two floors, where you can meet the resident artists and buy their handmade work. It really is *the* place to make, see and buy contemporary craft and design in the North West. Here you will find painters, sculptors, jewellers, print makers and all manner of other talented folk, collectively earning this hidden gem, which received the Best Independent Tourism Retailer award at Manchester Tourism Awards in 2011 and 2013.

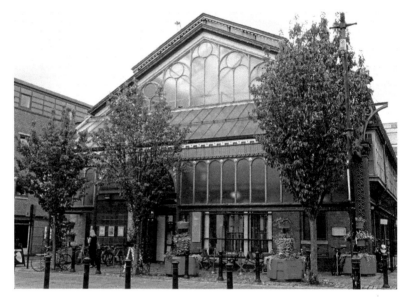

The Manchester Craft and Design Centre is housed in a former Victorian fish market building.

The resident artists work beneath the large glass roof. The eighteen studio boutiques are on two floors.

Manchester Craft and Design Centre

The centre also has a regular programme of contemporary exhibitions and exciting events, talks and workshops. Manchester Craft and Design Centre is charged with having sparked the cultural regeneration of the area and is now in its thirty-second year. Its patron and Elbow front man, Guy Garvey, says 'If you like to give personal gifts, then there is nowhere better in the North West.' The in-house eatery, Oak Street Café Bar, serves delicious homemade food and fine coffee to hungry visitors.

The centre is the place to see and buy contemporary craft and design.

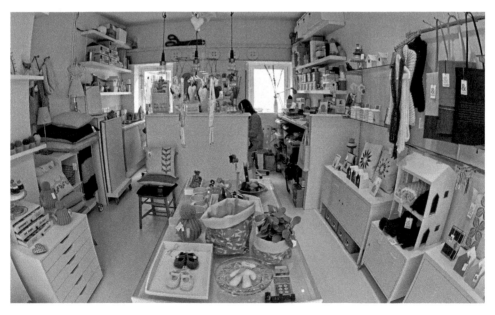

Meet the resident artists and buy their handmade work.

The Centre for Chinese Contemporary Art (CFCCA)

The Chinese Arts Centre was the original name for the CFCCA. It was founded in 1986 by a group of British Chinese artists based in Manchester, and became the CFCCA in 2013. It has a proud history of 'first' UK solo exhibitions, which have featured artists who have gone on to achieve international acclaim. The centre works with a wide array of partners to provide people with a lively and innovative programme of exhibitions, residences, engagement projects, festivals, symposia and events.

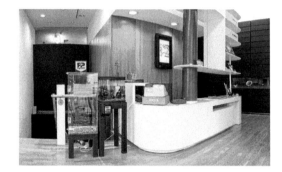

The reception area at CFCCA, where you will receive a warm welcome.

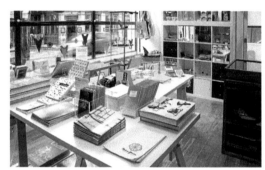

The CFCCA shop where the artists and designers can showcase their work.

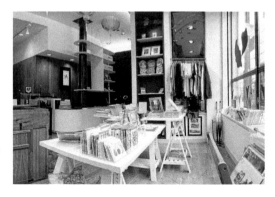

There are many unique and handcrafted items for sale in the shop.

The CFCCA aims to support the professional development of local, national and international artists by offering a variety of opportunities for them. The CFCCA works with four Asia-based associate curators to strengthen and inform the understanding of developments in East Asia.

The CFCCA shop provides a platform for artists and designers to showcase their work. There are many unique and handcrafted items for sale, prints and original or limited edition artworks.

The gallery space inside the CFCCA, where artists and designers have the opportunity to display their work.

The spacious galleries offer a great place for the artists to exhibit and for the visitors to view the work.

The 'Old' Fish Market

A fish market has used this site since the late eighteenth century. Old OS maps show that it was mostly an outdoor market, but, towards end of the eighteenth century, an iron and glass roof was constructed over the area. The wholesale and retail market dealt in fruit, vegetables, meat and fish, and their warehouses nearby were dedicated to the storage of fresh produce. The covered market hall was closed in 1972 and later demolished. The façade of the market itself now acts as the outside wall of a residential development.

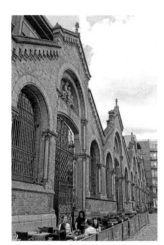
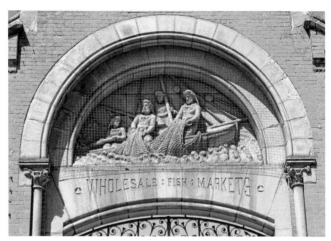
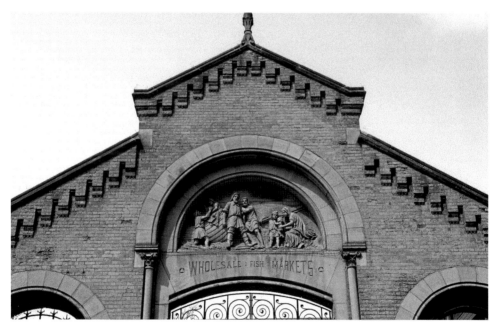

Top left: The old fish market façade is now the outside wall of a new residential development.

Top right: The friezes are by Henry Bonehill and they feature sculptures of fishing scenes.

Bottom: The wholesale fish market was built by Speakman, Son and Hickson in 1873.

5. AROUND SOUTHERN PICCADILLY

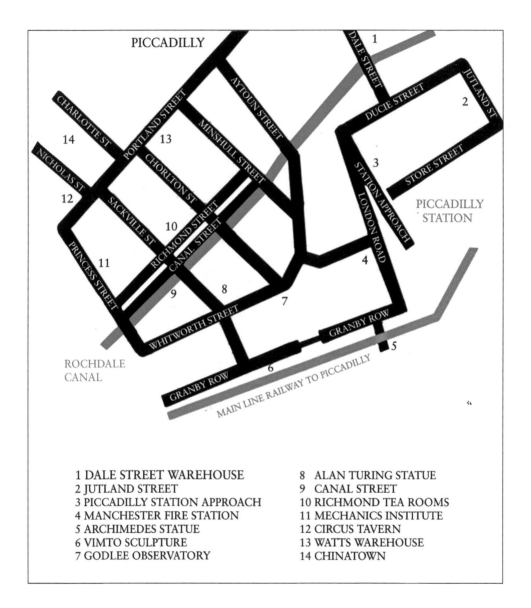

1 DALE STREET WAREHOUSE
2 JUTLAND STREET
3 PICCADILLY STATION APPROACH
4 MANCHESTER FIRE STATION
5 ARCHIMEDES STATUE
6 VIMTO SCULPTURE
7 GODLEE OBSERVATORY

8 ALAN TURING STATUE
9 CANAL STREET
10 RICHMOND TEA ROOMS
11 MECHANICS INSTITUTE
12 CIRCUS TAVERN
13 WATTS WAREHOUSE
14 CHINATOWN

Introduction to Southern Piccadilly

The Southern Piccadilly journey starts at Piccadilly Station, following the concourse along the curved building on Station Approach, which was designed by Richard Selfert and Partners. At the end of the approach, the regeneration project, transforming the Piccadilly Basin area into the 'jewel in the city's crown', can be seen developing around Ducie Street. The area now houses a mixture of office, residential and retail leisure space where modern architecture stands alongside historical buildings.

The Piccadilly Basin, the gateway to the outer part of the city, was formally a landscape of old mills and warehouses. The Rochdale and Ashton Canals converge near Ducie Street, where parts of the industrial past can still be seen. The waterways, towpaths and streets have been cleaned up and many of the old mill buildings have been refurbished.

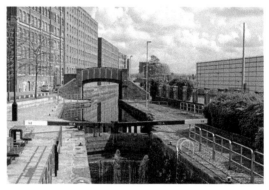

The Piccadilly Basin, the 'Gateway to the outer part of the city'. The Rochdale and Ashton canals converge near Ducie Street.

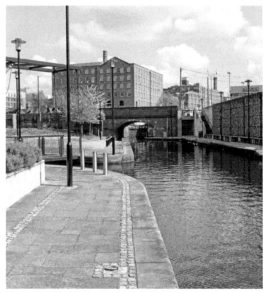

Regeneration of the canal area has been taking place, especially with the warehouses and towpaths.

The Rochdale Canal was officially opened in 1804 to allow goods to be transported into the heart of Manchester's industrial and commercial centre, linking the east of the city to the Bridgewater Canal at Castlefield. It was reopened along its entire length in 2002 after fifty years without through navigation. The canal forms part of the South Pennine Ring.

Canal Street, with its Gay Village, is one of the city's most famous areas; it is recognised as the UK's LGBT centre outside of London. The Gay Village is home to many yearly events, and Manchester Pride is the UK's most successful annual event of its kind. The main area is the attractive, pedestrianized street that runs along the west side of the Rochdale Canal. Within this thoroughfare are a variety of bars, clubs and restaurants.

Chinatown is one of the most colourful areas of the city centre frequented by visitors, families and tradesmen. It is an area with a strong sense of community. The traditions, festivals, arts and culture, and of course the food, all offer a rich and varied experience, whether it be a day out shopping or sampling an authentic Chinese meal in one of the restaurants in the evening.

Around the area are dotted landmarks of social and cultural history, such as the statue depicting Archimedes climbing from his bath under the mainline railway arches, the *Vimto* sculpture, celebrating the development of the famous drink in Granby Row, the Godlee Observatory, perched high on top of the University of Manchester's Sackville Street building, the Alan Turing memorial sculpture, which sits poignantly in Sackville Gardens and The Mechanics Institute, with its vibrant, stained-glass windows on Princess Street.

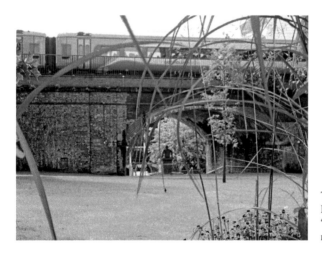

The tranquil green space on Granby Row, with Archimedes having his 'Eureka' moment beneath the busy railway line.

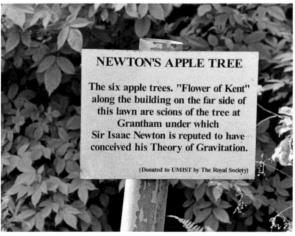

The six apple trees, on the edge of the lawn, are allegedly scions, shoots cut for grafting, of Sir Isaac Newton's famous gravity tree.

Dale Street Warehouse

The warehouse lies north of lock 84 on the Rochdale Canal. It is the only stone-built canal warehouse in Manchester and is now a Grade II* listed building. It was built for the Rochdale Canal Company in 1806. The four 'boat holes' allowed boats to unload its cargoes inside the warehouse. The Grand Arch was the entrance to the warehouses and wharves from Dale Street.

Above left: The magnificent four-storey building, dating from 1806, is made from millstone grit blocks.

Above right: The canal arm has been filled in and is now a car park. The warehouse, renamed Carver's Warehouse, has been converted into an office block.

Jutland Street

Jutland Street, originally named Junction Street, is one of Manchester's steepest streets. It was made famous in a drawing by L. S. Lowry in 1929, called *Junction Street, Stony Brow, Ancoats, Manchester.* It is 'pencil on paper' and is now on display at Manchester Art Gallery. It was the first Lowry acquired by the Gallery.

Above left: The cobbled sloping street, formerly called Junction Street was drawn by L. S. Lowry in 1929.

Above right: The area around Jutland Street has seen much redevelopment since the time L. S. Lowry sat at the bottom of the hill drawing the scene in front of him.

Piccadilly Station Approach

Gateway House on Station Approach was designed by Richard Seifert and Partners, 1967–69. The building has a long sweeping undulating façade with horizontals that are stressed throughout its length. The serpentine shape is suited to the sloping approach.

A view of the approach, looking south down London Road, showing Gateway House and Station Approach.

The sloping, elegant, curved-glass frontage creates an iconic building to the old London Road approach into Manchester. Gateway House is allegedly nicknamed the 'Lazy S'.

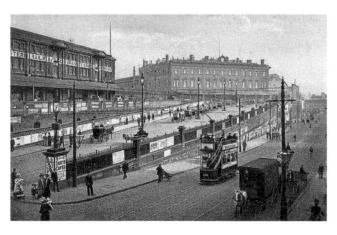

Station Approach and London Road circa 1900.

Manchester Fire Station

The fire station was opened in 1906. It is an Edwardian Baroque-style building, which was Grade II* listed in 1974. It was designed by Woodhouse, Willoughby and Langham, using red brick and terracotta, and cost £142,000 to build. The original building also housed a police station, ambulance station, a bank, the Coroners Court and a gas meter testing station.

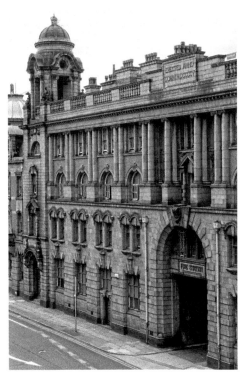 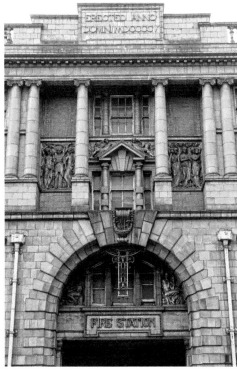

Above left: A view of the fire station taken from Station Approach. The construction started in 1904 and was completed in September 1906.

Above right: The building, of Edwardian Baroque architecture, is Grade II* listed.

Right: Manchester Fire Brigade and then the Greater Manchester Fire Service operated the station for eighty years from 1906 until it closed in 1986.

Archimedes Statue

The railway arches can be seen from the gardens in Granby Row. Hidden beneath one of them is an impressive statue of Archimedes emerging from his bath. The *Archimedes' 'Eureka!' Moment*, by Thompson W. Dagnall, was erected in 1990. Being so close to UMIST is an apt siting for Archimedes, as he was a significant Greek scientist and mathematician.

The Vimto Sculpture

The stained oak sculpture by Kerry Morrison was erected in 1992, close to where the company's original premises stood. The Vimto formula is a closely guarded secret, but it allegedly contains around twenty-nine ingredients. Herbalist John Noel Nichols made his first barrel in a terraced house on Granby Row. Vimto, a unique blend of herbs, spices and fruit essences, was registered as a trademark on 14 December 1912. It was described as 'a beverage for human use, not alcoholic, not aerated and not medicated'.

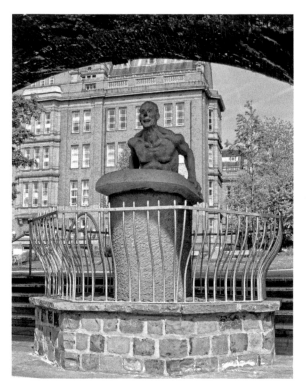 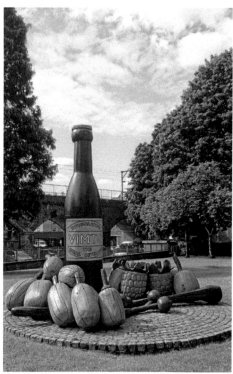

Above left: Archimedes taking a bath gave rise to the Archimedes Principle and his legendary 'Eureka!' moment.

Above right: The Vimto sculpture by Kerry Morrison stands in Granby Row, close to where John Noel Nichols produced his first barrel of his now famous drink.

The Godlee Observatory

At the junction of Aytoun Street, look up at the roofline of the Sackville Street building and the Godlee Observatory will be in view. It was built in 1902 and is still a fully functioning astronomical observatory, equipped with Godlee double telescopes, an 8-inch refractor counterbalanced by a 12-inch Newtonian reflector. Tours, mini lectures and slide shows can be booked at the observatory.

Above left: The Godlee Observatory sits high on the roof of the Sackville Building, University of Manchester.

Above right: The Godlee Observatory and telescopes were presented to the City of Mnachester in 1903 by Francis Godlee. The Manchester Astronomical Society, 'Manastro', holds weekly meetings and public lectures at the observatory.

Alan Turing Statue

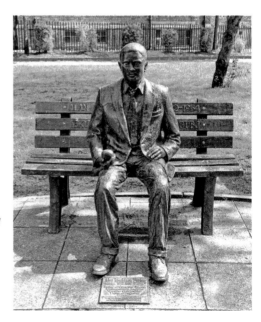

Alan Turing is known as the Father of Computer Science. The statue, by sculptor Glyn Hughes, was unveiled on 23 June 2000 on the thirty-ninth anniversary of his birth. Alan Turing's invention of the 'Bombe' at Bletchley Park was credited with helping the Allied Forces win the war. The 'Bombe' was able to decode encrypted messages sent from the German Enigma machine.

'We can only see a short distance ahead but we can see plenty there that needs to be done' was the final sentence in his *Computing Machinery and Intelligence*, written in 1950.

The Alan Turing Statue is located in the small public park called Sackville Gardens.

Canal Street

Canal Street is the centre of the Manchester Gay Village and has grown to become one of Europe's most lively gay areas. It is a pedestrianised street that runs alongside the Rochdale Canal. The canal was a trade route through the city during the nineteenth century. The many bars, clubs and restaurants ensure that this is a lively and vibrant area, especially at night. The area was celebrated in the *Queer as Folk* television drama and boasts some of the best bars in Europe.

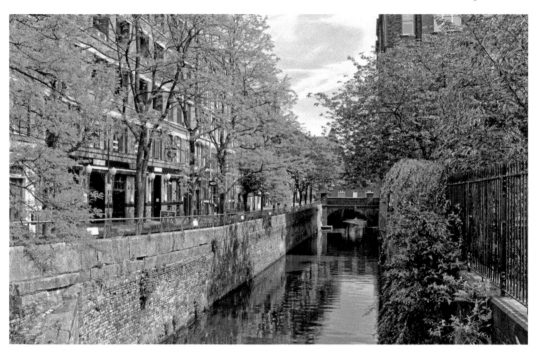

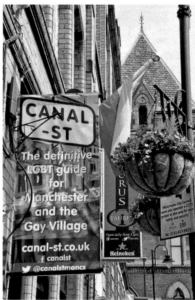

Above: The canal was once a trade route through the city. It links up with the Bridgewater Canal in Castlefield.

Below left: The Gay Village has one of the most vibrant nightlife scenes in the city. It's rather more peaceful during the day.

Below right: The foliage, flowers, flags and posters help to make Canal Street a colourful area.

Richmond Tea Rooms

Richmond Tea Rooms is situated on Richmond Street. It is run and owned by Nicholas Curtis and Andrew Underwood. It is a traditional English style tearoom. The decor, by Tim Burton, is very lavish and extravagant, but the menu offers unique specialities while also providing the traditional favourites. The cocktail lounge, with its quirky fixtures and fittings, offers the most delicious handmade cocktails.

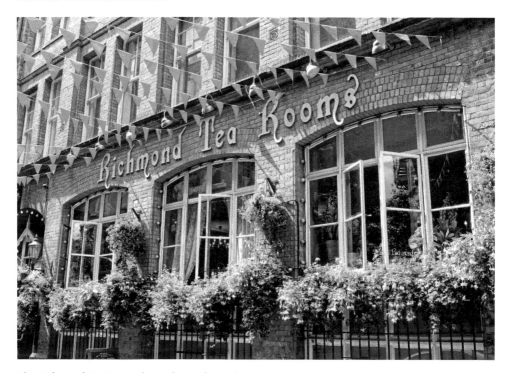

The Richmond Tea Rooms, located in Richmond Street, is a traditional English-style tearoom.

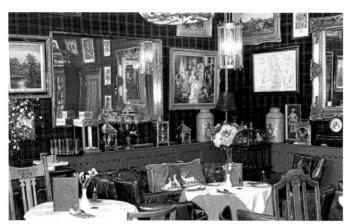

Above left: The interior decor, by Tim Burton, is stated in their website as being 'OTT'.

Above right: It's like stepping into a fairytale as soon as you walk through the doors. Its quirkiness is unique.

The Mechanics Institute

The Mechanics Institute is located on Princess Street close to the heart of Manchester city centre. The building is Grade II* listed and boasts a strong and proud history. The Mechanics Institute was originally located on Cooper Street and from this first institute grew the University of Manchester Institute of Science and Technology (UMIST) and Manchester Polytechnic. When the original building became too small and unsuited to its purpose, a new building was commissioned. It was designed by John Edgar Gregan and opened in 1857.

The Mechanics Institute building, which the National Museum of Labour History shares with the Manchester Trade Union Centre, has a long history, including being the venue of the first Trade Union Congress in 1868. The building was restored and the Congress Room refurbished and reopened as the Manchester Mechanics Institute in 1988.

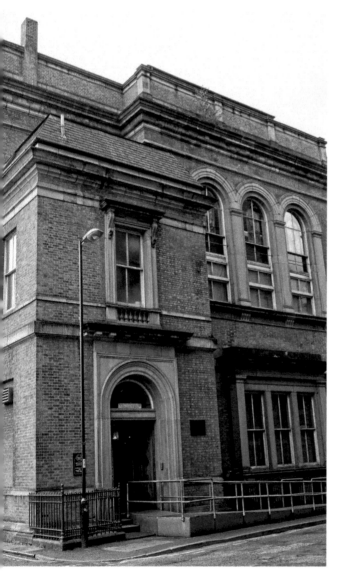

Left: The Mechanics Institute building was designed by John Edgar Gregan and opened in 1857.

Below: The Congress Room was refurbished, along with the rest of the building, in 1988.

The Mechanics Institute

Trade Unions have a long tradition of illustrative art on banners and badges. The Mechanics Institute has its own unique take on this in the form of several stained glass windows, which were installed in 1988 to commemorate the 120th anniversary of the first Trades Union Congress.

The Institute can certainly be called the birthplace of the TUC, a fact which was commemorated in the centenary year, 1968, when a plaque was placed on the building.

Above left: The Fire Brigade Union stained-glass window.

Above right: The Union of Construction, Allied Trades and Technicians stained-glass window.

The Circus Tavern

The Circus Tavern is allegedly the smallest bar in Manchester and Europe, and dates back to 1790, when it was a butcher's shop. It was transformed from a house into a public house around 1840. The name comes from the time when performers from the city's then permanent circus used to frequent it. It has two small rooms, a tiny counter and walls covered in photos.

The Circus Tavern, situated on Portland Street, dates back to the 1790s. It's small in size but huge in atmosphere.

Watts Warehouse

Watts Warehouse is a large ornate Victorian, Grade II* listed building. It was opened in 1856 as a textile warehouse for S & J Watts. It was built by Travis and Mangnall between 1851 and 1856, at a cost of £100,000. The design is in the style of a Venetian palazzo, with five storeys each decorated in a different style: Italian Renaissance, Elizabethan, French Renaissance, Flemish with roof pavilions with large Gothic wheel windows. The interior has similar lavish decoration. It is now the Britannia Hotel.

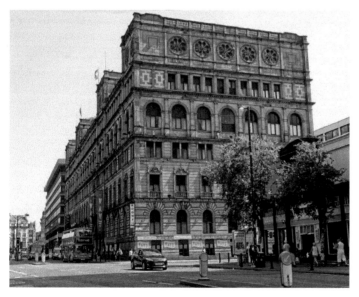

The Grade II* listed building is made from sandstone ashlar with a granite base. The massive building is 100-foot high, 300-foot long and 90-foot deep, with twenty-three bays along Portland Street and seven bays at each end. It was the biggest wholesale drapers in Victorian Manchester.

Chinatown

Manchester's Chinatown is the second largest in the UK and the third in Europe, and is known as the Chinese Village for the North of England. The *Paifang*, a traditional Chinese architectural gating-style arch, was specially built in China and then shipped over to Manchester. The structure was a gift from Manchester City Council to the Chinese community. The archway was completed in 1987.

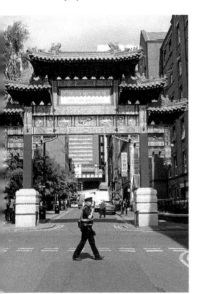
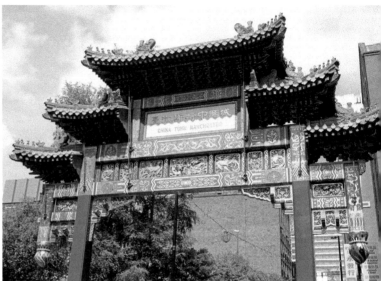

Top left: The Chinese *Paifang* stands at the boundary of Chinatown. It marks the boundary between the host society and the Chinese community, hence separating the two social and cultural spaces.

Top right: The *Paifang* has two pillars that support the elaborate roof-like structure. This *Paifang* is one of the largest Chinese arches in the UK.

Above: The archway is located in Faulkner Street and was a gift from China. Very few Chinatowns around the world have been given this honour.

6. AROUND ALBERT SQUARE, ST PETER'S SQUARE AND OXFORD ROAD

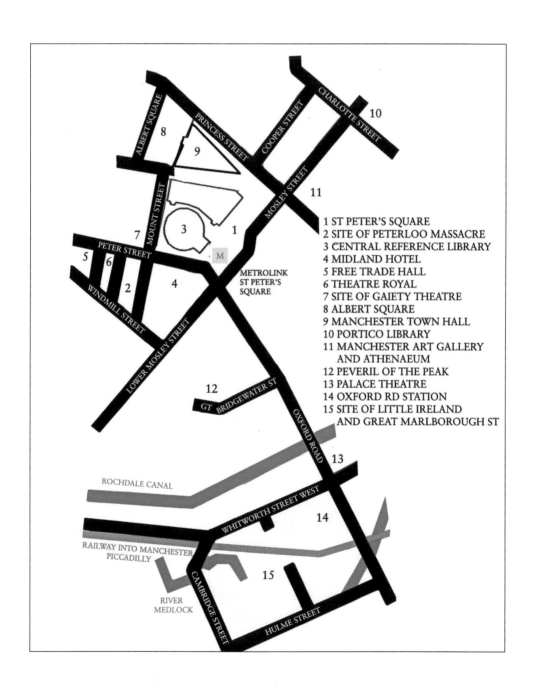

1 ST PETER'S SQUARE
2 SITE OF PETERLOO MASSACRE
3 CENTRAL REFERENCE LIBRARY
4 MIDLAND HOTEL
5 FREE TRADE HALL
6 THEATRE ROYAL
7 SITE OF GAIETY THEATRE
8 ALBERT SQUARE
9 MANCHESTER TOWN HALL
10 PORTICO LIBRARY
11 MANCHESTER ART GALLERY
 AND ATHENAEUM
12 PEVERIL OF THE PEAK
13 PALACE THEATRE
14 OXFORD RD STATION
15 SITE OF LITTLE IRELAND
 AND GREAT MARLBOROUGH ST

Introduction to Around Albert Square, St Peter's Square and Oxford Road

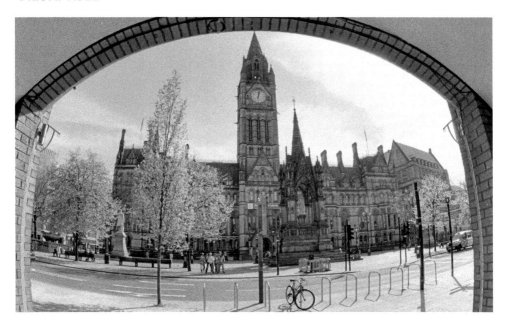

Albert Square is dominated by the huge Gothic presence of Manchester Town Hall.

Picking your way through the crowds of shoppers and business people coming and going from the Metrolink station, it is hard to imagine that this area was once a semi- rural space on the southern outskirts of the village of Manchester.

Early maps from the eighteenth century show the area as open fields sloping down to the River Tib, with only the occasional dwelling dotted around the landscape. The river followed the line, which is now Cooper Street, and flowed down to meet the River Medlock at Gaythorn.

The basic shape of the town hall footprint was occupied by blocks of houses and gardens, with the area around Albert Square – then called Longworth's Folly – similarly laid out with poor quality residential dwellings. However, by the mid-point of the nineteenth century, the area had been redeveloped with a much denser mixture of houses and commercial premises. The site of the town hall housed the fire brigade and the corporation workshops in a development called Town Yard. The fine buildings that now surround the town hall and Albert Square were built at the time of the Victorian boom years, and it is fortunate that most of them survive to this day. The paved area outside the town hall was originally a traffic island up until the mid-1980s, when it was redeveloped into the open space that is today, well used for concerts, functions and the Christmas markets.

The area around St Peter's Square, once known as St Peter's Field, has, of course, a unique place in the social and political history of the city when, on 16 August 1819, cavalry charged into a peaceful crowd of over 60,000 people who had gathered to demand the reform of parliamentary representation. The Peterloo Massacre, as it became known, claimed the lives of at least eighteen people, including women and children who died from trampling and sabre cuts.

St Peter's Square

St Peter's Square has undergone a significant redesign since 2013, and is now home to a major Metrolink station serving the area around the Central Reference Library and the town hall.

The area around St Peter's Square was named after St Peter's church, which previously stood on the site, but was demolished in 1907 and replaced by the Cenotaph. The Manchester Cenotaph is the work of Sir Edward Lutyens and is similar to the Cenotaph in Whitehall, London. It was inaugurated in 1924 and remembrance services have been held there ever since. As part of the recent redevelopment, it has moved from its central position in the square to the outside of the town hall extension.

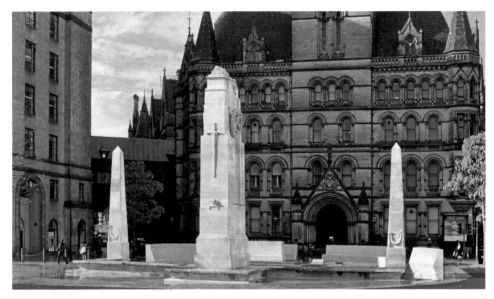

The Cenotaph has been moved from its original position to the fat end of St Peter's Square, beyond the library extension.

The Cenotaph in its original position in 1953, decorated for the coronation of Queen Elizabeth II.

The Peterloo Massacre

The area around the square is the site of the Peterloo Massacre, which took place on 16 August 1819. It was here that eminent speakers of the day, such as Henry Hunt, Richard Carlile, and Samuel Bamford gathered to address the public on the need for the reform of unfair working practices.

When the speakers arrived at about 1.20 p.m., the estimated size of the crowd was around 80,000. When the Bouroghreve could not clear a path through the crowd from the magistrates' house to the stage, he panicked and decided the town was in great danger. The cavalry were sent in to clear the way, and hacked and slashed their way through the peaceful crowd. Within 10 minutes, the crowd had panicked and fled, leaving St Peter's Field littered with men, women and children dead or dying from terrible injuries.

The speakers were arrested and imprisoned, and the Government attempted to suppress news of what had happened. However, compensation was paid to all the victims and a list of those killed, together with the amounts of compensation given, is held in John Rylands Library. When the town hall was opened in 1877, councillors asked artist Ford Maddox Brown to omit any reference to the Peterloo Massacre in his mural for the great hall, in case it might have caused Victoria some offence.

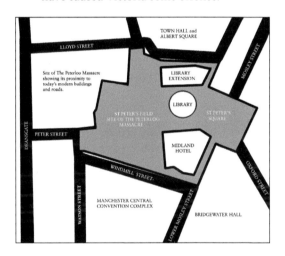

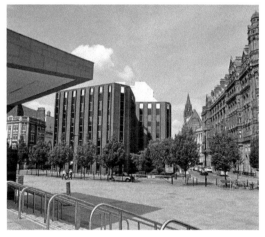

Above right: This view along Windmill Street marks the area of St Peter's Field where the 15th Hussars, The Cheshire Yeomanry and The Manchester Yeomanry drove into the crowd.

Right: A plaque on the side of the Free Trade Hall building is the sole reminder of the terrible events of that day. It is interesting to note that, even today, there is no proper memorial to those killed, and that it was not until the later years of the twentieth century that police horses were reintroduced to control crowds in the city.

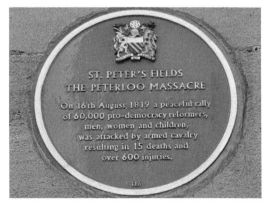

Central Reference Library

The Central Reference Library was designed by E. Vincent Harries and was constructed between 1930 and 1934.

The Library contains a number of rare collections, including much literary and historical material. It houses archive material relating to the works of Elizabeth Gaskell, first editions of Coleridge, early works of the Brontës and an extensive collection of early children's literature. Its theatre collection contains archive material from Manchester's theatres dating from the mid-eighteenth century to the present day, including programmes, posters, photographs and manuscripts.

The Henry Watson Music Library contains a vast collection of printed music and books. Visitors can compose their own music using the library's computers and mixing desk. There is also an extensive collection of BFI material, with access to highlights from classic British television.

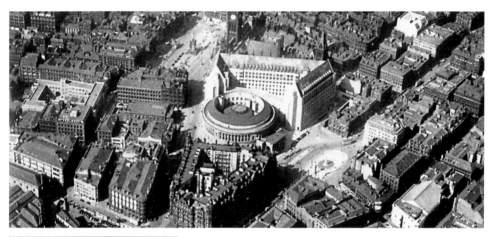

Above: An aerial view showing the Central Reference Library and its extension in 1938, just after its opening. It sits as a clean white building in sharp contrast to the blackened Victorian buildings in its vicinity. The covered walkway linking Central Station to the Midland Hotel can be seen in the lower half of the picture. The old Mechanics Institute building can be identified, sitting in Albert Square to the right of the town hall extension.

Left: The Shakespeare hall is an ornate chamber with a central window designed by Robert Anning Bell, which depicts William Shakespeare and scenes from his plays. There are also side windows depicting the coats of arms of the city of Manchester, the University of Manchester and the County and Duchy of Lancaster.

Midland Hotel

The Midland Hotel was built between 1898 and 1903. The hotel was designed by Midland Railway architect Charles Trubshaw, and was an impressive structure considered to be the height of luxury. The cost of the building was over £1 million and was initially intended to be a grand frontage to the station approach. In its heyday, it contained 400 bedrooms, four restaurants, electric lifts and a winter garden. It also had and a theatre containing 800 seats from which Mrs Horniman founded England's first repertory theatre company.

The hotel has had many famous guests throughout its history. Queen Elizabeth, the Queen Mother, dined there after a Royal Variety performance in 1959. Charles Stewart Rolls met Frederick Henry Royce there in 1904, leading to the formation of the world-famous motor company. In their early years, The Beatles were refused entry to the French restaurant for being inappropriately dressed.

The Midland Hotel was one of the few buildings to survive the intense bombing of the city centre on the night of 22 December 1940. US intelligence reports suggested that Hitler had seen pictures of the Midland Hotel and coveted it as a northern headquarters should the invasion of Britain be successful, and had ordered the area around the Midland to be spared from bombing. Although this was never substantiated, given that Central Station, the Great Northern Warehouse and the Castlefield Canal Basin were in close proximity, and were relatively untouched, it is possible there is some truth in the story.

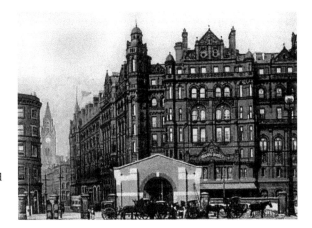

In its early days, the hotel had a covered walkway between the station and its entrance to protect those arriving from the worst elements of the weather.

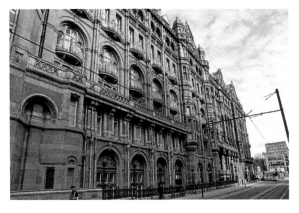

The Midland Hotel contains much polished granite, terracotta, faience and ceramic wares and blocks, which were popular because of their resistance to smoke and soot – especially suitable for use in cities.

The Free Trade Hall

There can be few buildings in Manchester that have such political and cultural importance as the Free Trade Hall. Originally built in 1838 as a wooden structure to hold meetings of the Anti-Corn League, it was replaced with a brick structure that was a venue for concerts and entertainments in 1842, before finally being replaced the building we know today, designed by local architect Edward Walters in 1856.

Over the years, it has housed meetings of fierce political debate, been the venue for the orchestration of political and social change, and contributed to the musical heritage of the city. Benjamin Disraeli's landmark speech in support of Conservative principles in 1872, Winston Churchill's passionate address on the importance of free trade, Mussolini's address to the British Union of Fascists in 1933 and Christabel Pankhurst's forceful ejection from a Liberal Party rally in 1905 are some of the key political moments in its history. Musically and artistically, Manchester's first cinema show, a programme of Lumiere Brothers' films took place in 1896. Elgar's first symphony previewed in the hall in 1908, and it was home to the Halle Orchestra from 1951 to 1996. On a different musical scale, The Sex Pistols played their first concert outside London to an audience of about forty on 4 June 1976.

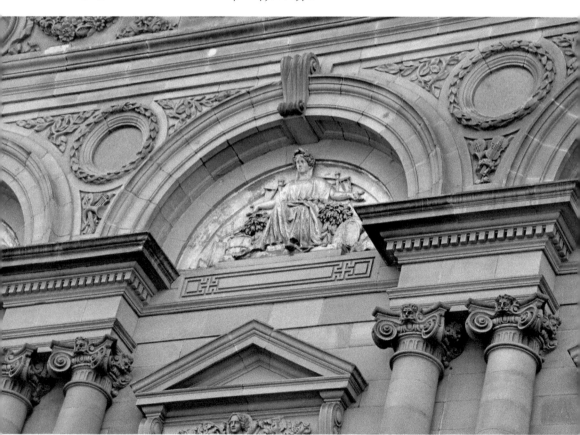

The top of the Free Trade Hall building is decorated with friezes of allegorical figures, the centre one of which is the open-handed figure of Free Trade, flanked by sheaves of corn and backed by sails, masts and rigging.

Bob Dylan and 'Judas'

The most legendary performance, however, must have been that given by Bob Dylan on Tuesday 17 May 1966. Dylan arrived at the Free Trade Hall as part of his European tour of 1966. The first half of his show was a solo acoustic set, which was well received. It lasted for about 45 minutes and ended with the classic 'Mr Tambourine Man'. However, for the second set, Dylan introduced an electric backing group, The Hawks, and swapped his acoustic guitar for a Fender Stratocaster.

During this set, there was a sense of Dylan changing from folk singer to pop singer and almost trivialising the songs that contained strong social and political messages. Midway through the set, a girl in the audience handed a note to Dylan from the front of the stage, which read, 'Send the band back home'. Dylan read it, slipped it into his pocket, bowed and carried on. Dissent in the audience grew, culminating in a shout of 'Judas' by one audience member just before the final number 'Like A Rolling Stone'. Dylan's reaction to the 'Judas' shout was, 'I don't believe you', followed by, 'You're a liar!', after which he drove into the final song in a totally uncompromising manner.

Right: Dylan's set included favourite songs that the audience expected to be delivered in acoustic style.

Below: The concert was part of Dylan's 1996 world tour, which started in Louisville on 4 February 1966 and ended in London on 27 May 1966.

PROGRAMME

free trade 17/5/66

It is not possible to print a list of songs Bob Dylan is to perform as he invariably makes up his programme shortly before the performance, sometimes during the course of it. This space has therefore been left to enable the programme holder to list the songs Bob Dylan sing

REE TRADE HALL - MANCHESTER

to Burns presents—

BOB DYLAN

TUESDAY, MAY 17th, 1966

at 7.30 p.m.

TALLS - - 20/-

G 33

Albert Square

Albert Square is situated on what was once derelict land that contained poor housing and bordered the River Tib. The regeneration of the square came about through the desire of Manchester Corporation to erect a memorial for Prince Albert who died of typhoid in 1861.

The Albert Memorial is a Grade I listed structure designed by architect Matthew Noble and set in a medieval–style Gothic canopy designed by Thomas Worthington. Within the canopy, there are symbolic figures representing art, commerce, science and agriculture. Below these stand secondary figures representing particular disciplines: the four arts, commerce, the four sciences, and agriculture

Work on the square was completed between 1863 and 1867, and the Manchester Bricklayers' Protection Society donated 50,000 bricks and an expression of sympathy towards the Queen's loss. Construction problems arose due to the culverted nature of the land and several buildings had to be demolished, including The Engraver's Arms pub, a smithy, a coal yard, a coffee roasting house and several warehouses. In the end, the donated bricks were used up in the foundations alone.

Below left: Albert Square was originally laid out in the form of a traffic circle with a group of bus stops until it was pedestrianized in 1987 and laid out with granite setts, York stone paving and cast iron street furniture.

Below right: Prince Albert's canopied statue is the largest of a number of monuments and memorials in the square.

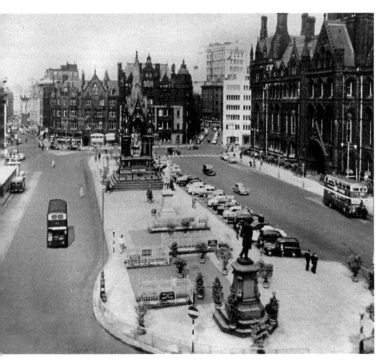

Albert Square Statues

Apart from Prince Albert himself, a number of sculptures populate the square, giving an insight those who have had an influence on the city over the past two centuries.

The statue of James Fraser (by Thomas Woolner), Bishop of Manchester, 1818–85, stands on a granite plinth facing outwards from the square. The plinth contains three bronze panels that show the bishop attending the sick, meeting industrial workers and mingling with his congregation. Next to James Fraser is John Bright (by Albert Bruce-Joy), a Quaker, British radical and statesman who, in partnership with Richard Cobden, founded the Anti-Corn League in Manchester in 1838. He was one of the greatest orators of his generation.

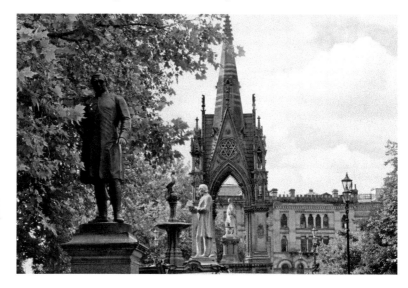

The statues of James Fraser and John Bright stand next to Prince Albert on the northern side of Albert Square.

On the southern side of the square can be found Benjamin Heywood, (by Albert Bruce-Joy), who was educated at Eton, and, as director in Heywood's Bank, the family business, sponsored many philanthropic causes, including The Mechanics Institute, Manchester Grammar School and Owen's College. He was elected High Sheriff of Lancashire for 1888. William Gladstone (by Mario Raggi) held the office of Prime Minister four times between 1868 and 1894, and visited Manchester on several occasions. He was popular for his advocacy of elementary schools and the free press.

The southern side of Albert Square contains the statues of William Gladstone and Benjamin Heywood.

Manchester Town Hall

In 1867, the city was still recovering from the devastating ecomonic effects of the cotton famine, so it might seem strange that the year heralded the commissioning of a new town hall for Manchester which, by the end of its construction, would be the world's costliest building. Alfred Waterhouse's design was considered to be the best in terms of lighting, ventilation and ease of access. It was officially opened on 13 September 1877 before a crowd of 66,000 people. Queen Victoria, however, was a notable absentee. It is possible that she was still in deep mourning for Prince Albert.

The clock tower contains a bell called Great Abel, named after Abel Heywood, who was the Mayor of Manchester at the time. Made by Gillet and Bland, the clock mechanism was started on New Year's Day 1879, and the inscription on the three clock faces reads, 'Teach us to number our Days'. There are twenty-four bells in the tower, but Great Abel dominates them all with a weight of 8 tons, 2 cwt.

The exterior of the town hall contains a series of statues of those who shaped the history of the town. One of the least expected sculptures can be found on the north side of the building in Princess Street. Edward III had been impressed by the Flemish weavers he encountered while fighting on the continent. He invited some back to England to pass on their weaving skills to local workers, and a group of these tradesmen settled in Ordsall near the city centre. 200 years later, their descendants were joined by the Huguenots, who were also skilled weavers and escaping persecution in France. Their combined skills put Manchester on the textile map.

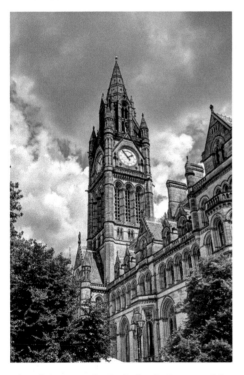

Above left: At 281-feet high, the clock tower of the Town Hall was, until 1962, Manchester's tallest building.

Above right: The frieze to the Flemish Weavers can be found on the north side of the town hall.

The Portico Library and Gallery

The origins of the Portico Library can be traced back to a visit to the Liverpool Athenaeum by surgeon Michael Ward and his friend Robert Robinson, some ten years before the building was erected. Dismayed that Manchester lacked any comparable institution, they vowed to remedy the problem and commissioned Thomas Harrison, a leading exponent of classical architecture revival, to design The Portico, completed by David Bellhouse & Sons in 1806 at a cost of £6,881 5s 3d. It was an immediate success.

The Portico Library and Gallery is accessed by a small door at the side of the building in Charlotte Street. Climb the flight of stairs to the top, and you enter a large room containing an extensive collection of mainly eighteenth-century books, covering literature, science, theology, philosophy, politics and more.

Membership of the library is by subscription only, but entry to the public is free. Members can enjoy a range of benefits, which include access to the collections, borrowing rights, access to the Reading Room, Cobden Area and reading corner.

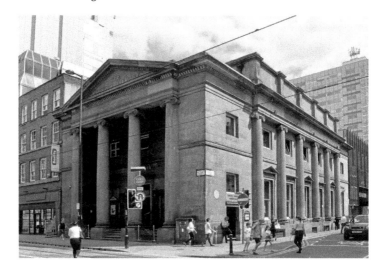

The library is the only surviving work by Thomas Harrison in the city and is Manchester's earliest Greek revival building.

The main room sits under an elegant glass dome and is the perfect place to study, research or enjoy one of the special exhibitions that are regularly held.

Manchester Art Gallery and Athenaeum

Work began on the building in 1829 and was completed by 1935. The building was immediately opened to the general public, although the admission charge of sixpence was a substantial outlay for many ordinary Mancunians.

The first picture bought for the new collection was James Northcote's study of the black actor, Ira Aldridge – *Othello, The Moor of Venice*. It is thought the decision may have been influenced by Manchester's place at the forefront of the anti-slavery movement.

There is also a significant collection of works by Pierre Adolphe Valette, who painted scenes from Manchester in the early years of the twentieth century. Foggy streets and canals dominate his work, and the busy industrialism of the town is atmospherically depicted. L. S. Lowry was one of Valette's students, and the influence of his tutor can clearly be identified in Lowry's work.

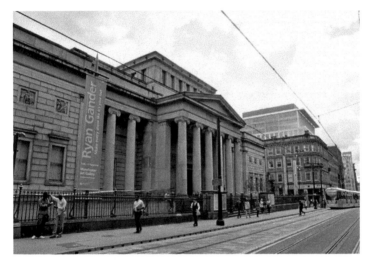

Situated in Mosley Street, Manchester Art Gallery houses many works of local and international significance.

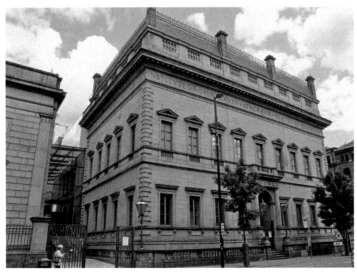

The Manchester Athenaeum sits behind the Art Gallery on Princess Street and is connected by a new glass hallway. The building once contained a newsroom, library, lecture hall, theatre and billiard room. The motto of its founding members, 'For The Advancement And Diffusion Of Knowledge', can be seen etched into the stonework.

The Theatre Royal and The Gaiety Theatre

Oxford Street and Peter Street have been thriving areas for theatre and entertainment over the years. The Theatre Royal was opened in 1845 and is the oldest theatre building in the city. It was commissioned by businessman John Knowles, and operated as a theatre up to 1921, when it closed in the face of growing competition from the Palace Theatre and the nearby Opera House.

Constructed in 1814, The Gaiety Theatre, or Comedy Theatre as it was first known, was bought by Ann Horniman in 1908 and became home for Britain's first regional repertory theatre. She encouraged a group of writers that became known as The Manchester School of Playwrights. They included Harold Brighouse, who wrote *Hobson's Choice*, and Stanley Houghton, who penned *Hindle Wakes*. It was demolished in 1959 and was situated on Peter Street, near the junction with Mount Street.

The Theatre Royal has had a variety of uses, which have included a cinema, bingo hall and night club.

The Palace Theatre

The Palace Theatre opened on 18 May 1891. It was designed by architect Alfred Darbyshire and built at a cost of £40,500. The opening production was a ballet of *Cleopatra,* and the theatre enjoyed much success until it suffered a downturn in audiences at the turn of the century. Threatened with closure, the management reviewed the range of entertainments on offer and the theatre experienced a significant revival in the first part of the twentieth century, with appearances by artists such as Judy Garland, Danny Kaye, Charles Lawton, Gracie Fields, Noel Coward and Laurel and Hardy.

The Palace Theatre is a landmark on the corner of Oxford Road and Whitworth Street. It was not always clad in beige tiles; these were only added to the building in 1956.

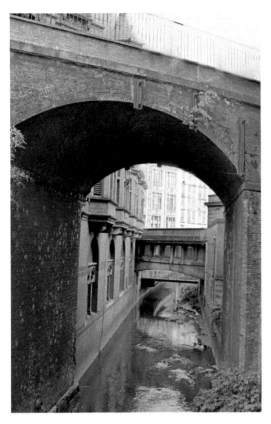

The River Medlock

The River Medlock is one of three visible rivers that run through Manchester, the others being the Irwell and the Irk. In its heyday, the river was navigable and mainly used by coal barges. Its banks regularly flooded and, in the days when it was used by factories and mills as an industrial sewer, one of the worst slums in the country clung to its banks.

The River Medlock still winds its way across city. At the time of Little Ireland, this section of its banks at Oxford Road would have been lined with factories disgorging toxins into the river.

Oxford Road Station

Oxford Road Station was opened on 20 July 1849 as the city terminus of the Manchester South Junction and Altrincham Railway. Initially, it had only two platforms and a number of temporary wooden buildings, but extra platforms were added in 1857 due to demand created by the Manchester Art Treasures exhibition of that year.

The current building was fashioned in 1960 by architects W. R. Headley and Max Glendennining. Its distinctive curved beams, which support curved platform canopies, resulted in the station being recognised as one of the most unusual stations in the country for architectural form and technological interest. It is currently a Grade II listed building.

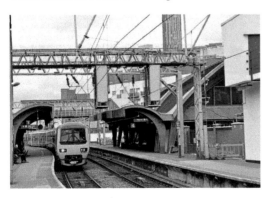

The distinctive curved roofs of Oxford Road Station are unique in terms of railway station design.

The Peveril of The Peak

The Peveril of the Peak, named after Sir Walter Scott's longest novel, is situated on Great Bridgewater Street, just off Oxford Road, and is a unique building. There are many architecturally interesting pubs with tiling on their interior wall, but this establishment has the tiling on the outside and presents a colourful, vibrant contrast to the red-brick warehouses that surround it. Inside, there are many interesting period features, including stained-glass leaded screening and cast-iron fireplaces with marble surrounds.

Three episodes of the 1993 TV detective series *Cracker* starring Robbie Coltrane and Christopher Eccleston were filmed in the Peveril of the Peak.

The Refuge Assurance Building Tower, Oxford Road

The tower of the Refuge Assurance building is one of Manchester's most famous landmarks for people travelling from the south into the city along Oxford Road. The building was designed by Alfred Waterhouse (who also designed Manchester Town Hall) and was constructed between 1891 and 1895. The tower, however, was added later. Rising to a height of 241 feet, it was part of extensions made to the building between 1910 and 1912.

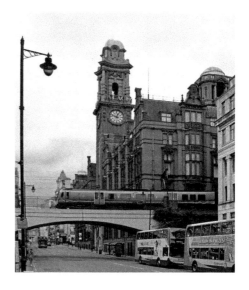

The clock tower today. A visit to Manchester Art Gallery will enable you to see Adolph Valette's painting of Oxford Road (1910), which shows the tower under construction, rising above the busy Edwardian street, wrapped in the hazy pollution of an industrial city.

Little Ireland

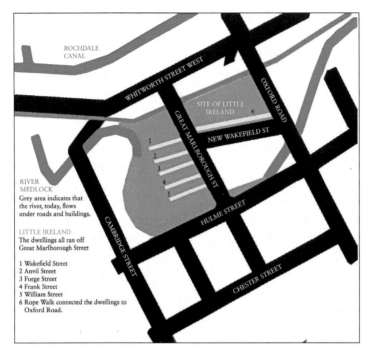

The area that was once Little Ireland was situated just off Oxford Road on the banks of the River Medlock.

Little Ireland was a small area of land surrounded by factories, and contained around 200 cottages that were inhabited by immigrants from Ireland between 1827 and 1847. Living conditions were appalling, and heaps of refuse, offal and human waste littered the streets between the dwellings, which were also surrounded by pools of stagnant water. The window tax meant that many of the windows were boarded up, denying the inhabitants access to light and air. On average, around twenty people lived in each cottage, which consisted of two rooms, an attic and a cellar that often flooded. One outside privy served around 120 people, and there were constant fears about the outbreak of cholera.

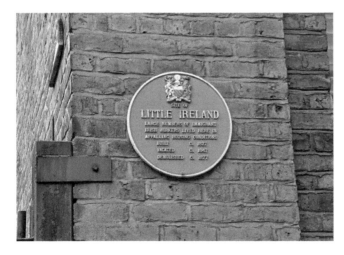

Little Ireland is remembered by a plaque situated on Great Marlborough Street just south of the railway station.

The trainline that runs through Oxford Road Station did not exist at the time of Little Ireland. The railway terminated at Central Station about half a mile to the north.

Standing on Oxford Road today, the natural depression in the ground that marked the entrance to the slums can still clearly be seen and incorporates a number of public houses that are set well below the level of the road. The poor living conditions would have been made worse by this location, with water draining into the hollow and damp hanging in the air around the banks of the river.

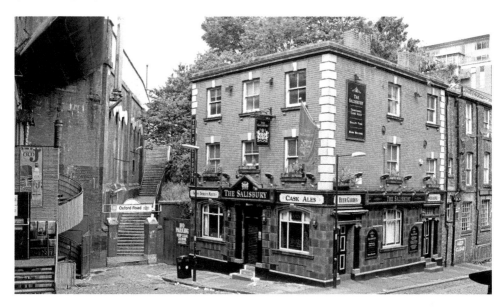

Above: The dip of land on Oxford Road, just south of the railway station, marks the spot where the entrance to Little Ireland from Oxford Road stood.

Right: Great Marlborough Street today. Modern factories and high-rise student accommodation stand where there was once poverty, overcrowding and disease.

Views Across Our Changing City

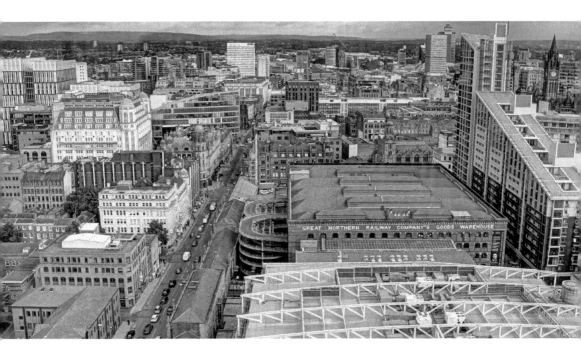

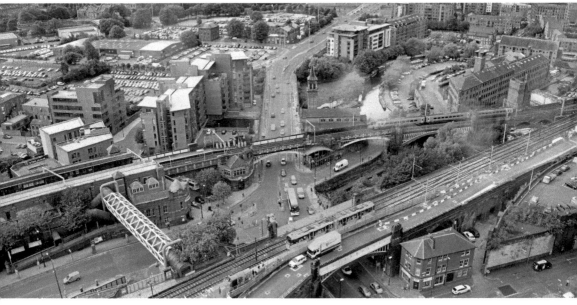

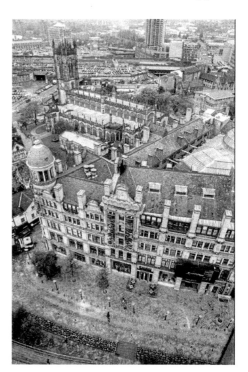

Right: A unique view of The Triangle taken from the top of the Manchester Eye, before it was resihted to Piccadilly Gardens.

Opposite above: Looking north-east across the ever-changing face of Manchester's city centre. The low-rise Victorian buildings and today's high-rise structures sit snugly together. The Pennine range, which can be viewed in the background, gives rise to the skies and the showers of rain that Mancunians and the city's visitors 'occasionally' receive (Photo taken from Cloud 23).

Opposite below: Looking south-west across the city, the A56 carries traffic away from the centre of Manchester out to the westerly suburbs. The main railway line, and the Metrolink tram network, carry passengers across the Bridgewater Canal Basin in and out of the city.

About the Authors

Ian Littlechilds and Phil Page are professional photographers and writers who have been working together on a number of photographic projects since 2005. After running a wedding photography business for over five years, they embarked on book projects to further improve their photographic, writing and research skills. Both have lived and worked in Greater Manchester for over thirty years. This is their third publication with Amberley, their previous two being *The Four Heatons Through Time* (2012) and *River Mersey Source to Sea* (2013). In addition to writing, they deliver talks on local history to community groups in Greater Manchester, regularly contribute articles to local publications, and run workshops on the development of photography skills to both adults and children.

Acknowledgements

We would like to thank the following people and organisations who have helped us to compile the information for this book:

The Royal Exchange Theatre; The Peoples History Museum; The Portico Library; The Museum of Science and Industry; The Revd Nigel Ashworth, Rector at St Ann's church; Hilton Group Ltd; Barbara Brooks; Alan Myerscough, Organist and Chapel Keeper, Cross Street Unitarian chapel; Joanne Marshall at The Mechanics Institute; W. Rhodes Marriott for the 1953 picture of St Peter's Square; Sarah Gee at the Centre for Chinese Contemporary Art; Andrew Underwood and Nicholas Curtis at the Richmond Tea Rooms; the Staff at Beatin' Rhythm Records and Piccadilly Records.

We would like to thank all those listed above for permission granted to use copyright material in this book. Every effort has been made to trace copyright holders and to obtain permission for the use of copyright material.

We would like to acknowledge the following publications, which we have used to research facts about city centre:

Hartwell, Claire, *Pevsner Architectural Guides* (2001).
Hylton, Stuart, *The Little Book of Manchester* (2013).
Morley, Paul, *The North (And Everything In It)* (2013).
Nevell, Michael, *Manchester: The Hidden History* (2012).